HOW TO DRAW

Animals

A STEP-BY-STEP GUIDE FOR BEGINNERS WITH 10 PROJECTS

SUSIE HODGE

NEW
HOLLAND

First published in 2004 by
NEW HOLLAND PUBLISHERS (UK) LTD
London • Cape Town • Sydney • Auckland

Garfield House
86–88 Edgware Road
London W2 2EA
www.newhollandpublishers.com

80 McKenzie Street
Cape Town 8001
South Africa

14 Aquatic Drive
Frenchs Forest, NSW 2086
Australia

218 Lake Road
Northcote
Auckland
New Zealand

10 9 8 7 6 5 4 3 2 1

ISBN 1 84330 600 X

Senior Editor: CLARE HUBBARD
Editor: ANNA SOUTHGATE
Design: BRIDGEWATER BOOK COMPANY
Photography: SHONA WOOD
Editorial Direction: ROSEMARY WILKINSON
Production: HAZEL KIRKMAN

Reproduction by Pica Digital PTE Ltd, Singapore
Printed and bound by Times Offset (M) Sdn. Bhd., Malaysia

NOTE
Every effort has been made to present clear and accurate
instructions. Therefore, the author and publishers can offer no
guarantee or accept any liability for any injury, illness or damage
which may inadvertently be caused to the user while following
these instructions.

Contents

Introduction

The earliest drawings that we know about are of animals, and many of them are remarkably lifelike considering the artists were using crude materials on cave walls. Animals continued to be the subject of many artists' work, from Stubbs' gleaming horses to Landseer's loyal dogs. Leonardo da Vinci sketched umpteen cats and Rembrandt rendered the wrinkled skin of an elephant with cross-hatching. Throughout his life Picasso created images of animals and could capture the essence of their character with just a few lines.

Today, animals are still among the most popular and appealing subjects for drawing, and yet many of us are reluctant to try because we think they are more difficult to draw than other subjects. In reality, no subject is more difficult to draw than another, and there are various techniques and methods that can help to simplify the process, allowing you to draw more convincing, lifelike animal portraits.

Everyone can learn to draw well – it just takes confidence and a little extra knowledge – and the enjoyment and satisfaction that it can bring is immeasurable. Animals are wonderful subjects: for their loyalty and personalities, for the way they move or for their markings and expressions. Our own pets – great characters and companions, hilariously funny one minute or cute and affectionate the next – can make the best models, not least because we know them so well. All animals can become charming drawings, the only problem being that

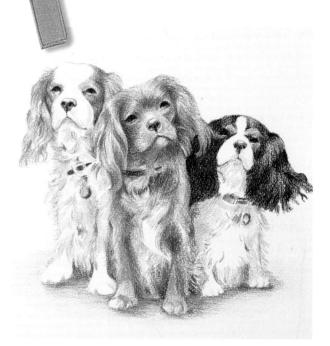

ABOVE Forget about failure – each time you put pencil to paper the task will become a little easier, the results just that bit better and the satisfaction even greater.

they're always on the move and that picture-perfect pose can be gone in an instant.

You can use photographs as references, but try not to rely on them too heavily. Drawing from photographs will help to build up your confidence, giving you time to study the subject at close hand without it moving away, but sketch from life as often as you can, as well. However brief or vague, this will help you to understand each animal in greater depth and your drawings will be freer and livelier as a result. Sketches needn't be complete drawings – just a few lines to indicate the spine, tail, eyes and whiskers can be enough to give the right impression.

Using the book

In addition to advice on animal anatomy, creating texture and capturing form, this book offers instruction on materials, techniques and composition. It explains methods of working that will help to avoid mistakes and pitfalls that are common when starting out. It explores how to show an animal's solidity, texture and facial expressions, how to portray character and personality and how to capture movement in order to keep an animal looking lifelike.

The book also features 10 clear, step-by-step demonstrations, each showing how to draw a particular animal using different materials and techniques. The demonstrations start off with a very basic drawing and build up to more detailed examples. The steps explain and illustrate numerous stages in the drawing's progress. Each demonstration focuses on a different technique and includes an alternative drawing of the same subject using different media, and an additional photograph of a similar animal for you to try drawing.

By following the tips and suggestions in this book you will develop both your confidence and your drawing style. Try to get into the habit of drawing a little each day and you'll soon become an expert.

FINAL DRAWING

ALTERNATIVE DRAWING IN A DIFFERENT MEDIUM

STEP-BY-STEPS

TRY A DIFFERENT ...

SUBJECT

ALTERNATIVE IMAGE

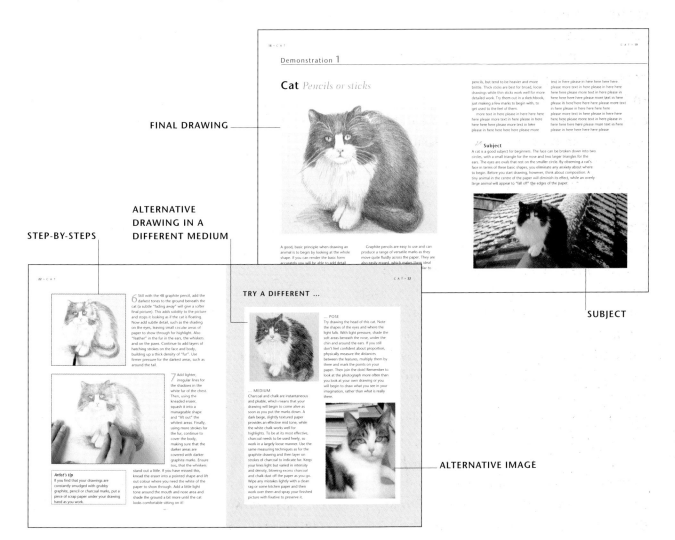

Tools and Materials

PENCILS

Pencils and paper are the starting materials for most people, but a ballpoint pen on the back of a cardboard box can be just as useful if that's all you have to hand when an irresistible image presents itself. Don't spend a fortune at first – you can collect new materials gradually, trying them out as you go along.

PENCILS Made of graphite and clay, pencils are available in varying grades of hardness – indicated on the pencils themselves. "H" on the pencil stands for hard; "B" stands for black (meaning soft) and "F" stands for fine. An "HB" pencil, therefore, is medium-soft, while a "2H" pencil is fairly hard and a "6B" is very soft. (The higher the number, the harder or softer the pencils become, relatively.) Tonal work can be more effective with softer pencils; the softness allows you to blend and can be erased without leaving an indent should you make a mistake.

Mechanical pencils are good for precision work, but the softest grades are not easy to find.

GRAPHITE STICKS These are made of solid graphite, usually without a wooden or plastic pencil casing, which makes it easy to use the side of the stick as well as the tip. Some graphite sticks have a lacquer coating or paper covering to protect your fingers to a certain extent. Water-soluble graphite sticks can be blended with water on the page for some interesting results.

COLOURED AND PASTEL PENCILS

WHITE CHALK This is available as a hard stick for detail and fine marks, or as a soft pastel, which can be blended more easily.

CHARCOAL and CHARCOAL PENCILS Among man's earliest drawing materials, these are sticks of charred wood (willow or vine), available in different thicknesses. Thin sticks work well for fur, feathers and other fine detail, while block charcoal works well for large areas. Compressed charcoal is heavy and produces a darker line, which is difficult to smudge or blend. Charcoal pencils come in a wooden casing, so are less messy and can give a sharper line. They are not easy to erase, however. They can be used to create contrasts and rich areas of tone.

CONTÉ CRAYONS, STICKS and PENCILS These are natural pigments bound with gum Arabic. The most popular colours are earth tones – white, black, greys, browns and rusts, such as sanguine and sepia – but they are also available in a wide range of other colours. They are effective for crisp, decisive lines and for large areas of tone. They can be smudged but are not easily erased.

PASTEL PENCILS These are harder than soft pastels and look like coloured pencils, although they have a scratchier, chalkier feel. They are good for detailed line work as well as shading as they are non-waxy and can be blended well. They come in many colours.

COLOURED PENCILS These are available in many different colours and forms, such as standard, water-soluble and thick/thin-leaded, and they vary in quality and softness. Some coloured pencils have a heavy wax

content and deep pigments, some have thin leads, which make defined lines, and others are clay-based and can be blended easily. Layering colours produces different shades, and interesting results can be achieved by using groups of colours in different sequences.

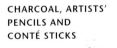

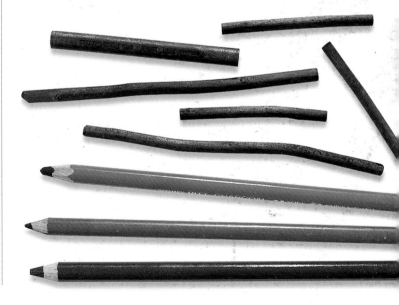

CHARCOAL, ARTISTS'
PENCILS AND
CONTÉ STICKS

PENS

PENS There are many different types of pen. Technical pens are convenient to use, but their nibs make unvarying marks. Dip pens are penholders with interchangeable, flexible metal nibs. Pointed nibs are best for detail and chiselled, or calligraphy, nibs can create effective fur. Fountain or cartridge pens, roller-ball, ballpoint, fine liners and specialist art pens come with a wide range of nibs and can be used for both quick sketches and more detailed drawings. All pens can create fine, flowing lines, with smooth and subtle results.

INKS Indian ink (which actually originated in China) is black, waterproof and dries fast. Other waterproof inks are available in various colours. Water-soluble ink can be diluted with water and blended to create different tones. Felt- and fibre-tipped pens can be bought in both waterproof and water-soluble versions.

PENS AND INK

SHARPENERS Craft knives and scalpels, with fixed or retractable blades, are good for sharpening pencils as they give you greater control over the shape and sharpness of the tip. They are also good for trimming dirty edges from erasers. If you prefer a regular pencil sharpener, ensure that the blade is sharp.

ERASERS and STUMPS These are useful for rubbing or "lifting out" mistakes, or for blending. Kneaded erasers, also known as putty rubbers, can be manipulated into small shapes for hard-to-reach places and for "lifting out" highlights in heavy tonal areas. Firmer, plastic erasers remove stubborn pencil or graphite marks and small errors.

For blending charcoal, chalks and pastel pencils, use a paper stump called a torchon or tortillon.

FIXATIVE This is resin that has been dissolved in a colourless spirit solvent, and which prevents drawings made with pencil, charcoal or other soft-pigment materials from being smudged. When sprayed on to a drawing the spirit solvent evaporates and a thin coating of resin is left behind, which binds the pigment dust to the support. Once fixed, even an eraser cannot alter a drawing. It is possible, however, to work on top of a

fixed drawing and it is common practice to fix a drawing periodically while it is being made. Fixative is best applied using a CFC-free aerosol, following the manufacturer's instructions. Bottles with a hand-operated spray and a mouth-spray diffuser are also available.

PAPER and SUPPORTS The surface of your paper determines the effect of the media used on it. Good-quality paper is neutralized to counteract acidity and will not become brown or brittle. It is usually labelled "acid-free". Cartridge (drawing) paper is standard. It can be white, cream or coloured and is available in various weights, sizes, qualities and quantities.

Pastel paper comes in a range of tints and has a "tooth" or grain, which is designed to capture and hold the tiny particles of colour. One side of the paper is usually textured, which is the side most people draw on, but you can use the other side if you prefer. Pastel paper comes in two weights; thicker paper can take heavier rubbing and reworking than lighter paper.

Watercolour paper is available in various weights and is good for all kinds of drawing. Hot pressed (HP) paper has a smooth surface, suitable for detailed work. "NOT" or cold pressed paper has a slight "tooth", which makes it good for most types of drawing.

Try out textured, coloured or handmade papers, card and specialist papers with coatings, such as velour paper. These can all add interest and another dimension to your work.

Sketchbooks are made with paper and card of various surfaces, colours and weights.

They come in many sizes and bindings and in both portrait and landscape formats.

DRAWING BOARDS and EASELS Securing your paper or support to a drawing board will make it easier for you to work. It might sound obvious, but make sure that the board is large enough for your paper and that its surface is smooth. You can buy a purpose-made drawing board from a good art shop or use a sheet of plywood or MDF (medium density fibreboard).

Easels come in many sizes, so choose one that you can sit or stand at comfortably. Some easels fold away into a drawing case. The most important consideration here is stability. An easel must be strong enough to hold your drawing board but also to take the pressure and weight you apply as you work. A practical choice is an adjustable table easel.

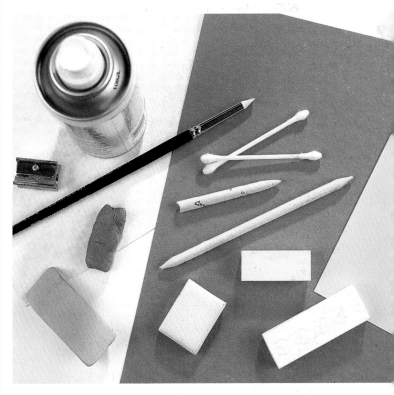

SHARPENERS, ERASERS, STUMPS, FIXATIVE, PAPER AND SUPPORTS

Basic Techniques

The first step to take when drawing is to develop your confidence. Try to overcome any worries of not drawing well or fears of making mistakes. Even the most proficient artists make errors; the secret is not to let this get in the way of your progress. Persevere, and your drawings will improve; practise makes perfect (or at least much better).

After confidence, the next most important area to concentrate on is observation. Most of us tend to draw what we *think* we see rather than what we *really* see. By training yourself to see what you are drawing as an objective series of tones and shapes – however peculiar it might seem at first – you will begin to draw with greater accuracy. This is the basis for all figurative art. Another useful tip is to develop a picture as a whole, and not to focus on just one part of the drawing at a time.

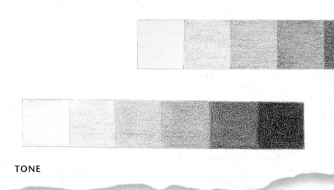

TONE

The techniques explained here will help you to gain dexterity and confidence and will improve your drawings once mastered.

LINE A good line drawing should lead the eye around an image. An unbroken line can appear clumsy, so vary the tone of a line by using a harder or softer pencil or a thinner or thicker stick of charcoal. Lines drawn with pen and ink will also look more convincing if they are broken or stippled.

TONE At first, it can be difficult to see tone as colours, textures, shapes and so on. But, by half-closing or squinting your eyes, you'll find that light and dark areas become exaggerated and are easier to distinguish. To develop your "tonal dexterity", draw a long rectangle and divide it into five or six equal sections. Using a soft pencil, graphite stick or dark-coloured pencil, colour the first section as dark as you can. In each subsequent section, shade a little lighter each time until you reach the last section, which should be left white. When you have finished, check that your tonal scale is smooth and that there are no obvious "jumps" between

LINE

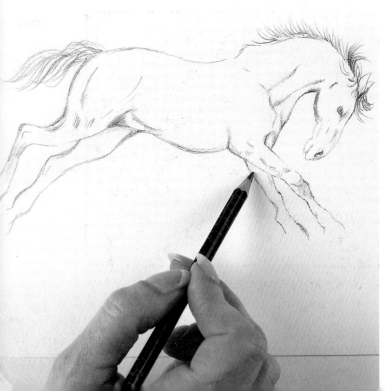

TONE

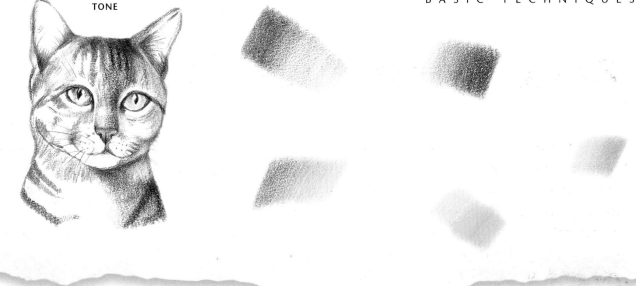

sections. Refer to this tonal scale when drawing and always try to use the full range of tones.

For the same smooth shading or blended tones without the sections, colour (or render) up and down, as dark as you can at first, and lighten your pressure as you move across the paper. Keep your lines close together so that they fill in any spaces. With practice, you should be able to control your pencil or graphite stick to create smooth gradations in tone. Take care not to smudge your work, or it will look grubby.

If you are using white paper, let the paper show through for your lightest tones; if using coloured paper, use white chalk or white ink for the highlights.

HATCHING This is a method of applying tone using a series of lines. The lines can be drawn close together for dense tones or spaced apart to create lighter tones. Curved hatching can be used to represent wavy fur.

CROSS-HATCHING This also uses lines, where one series of lines is crossed by another, at an angle. Use cross-hatching where you want dense tone.

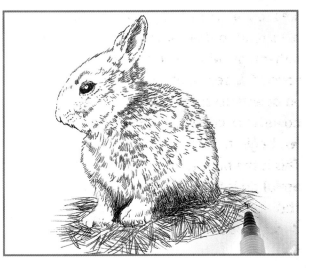

HATCHING AND CROSS-HATCHING

HATCHING AND CROSS-HATCHING

STIPPLING Also called pointillism, this is where dots are placed close together or far apart in order to create dark and light tone. Cross-hatching and stippling work particularly well with pen and ink.

"LIFTING OUT" Use a plastic or kneaded eraser to "lift out" highlights on a drawing. This creates clean highlights wherever you want them.

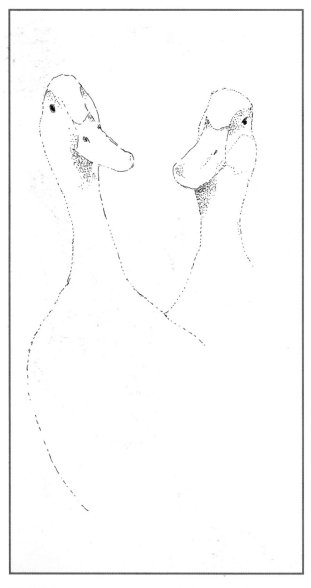

STIPPLING

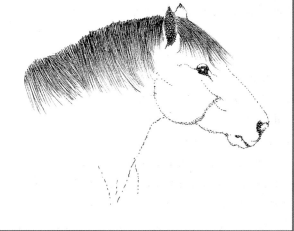

STIPPLING AND HATCHING

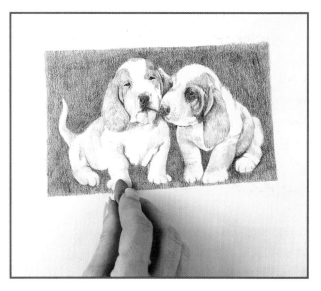

"LIFTING OUT"

TEXTURE This is all-important when drawing animals. The woolly fleece of a sheep, the smooth feathers of a duck, the shaggy fur of a terrier and the fluffiness of a cat can all be extremely satisfying to draw. Hair, fur, colouring and markings define the species and the character of an animal and before you even begin to draw you should consider what kind of paper would help you to show these individual features and select your media accordingly. Graphite, Conté, pastel pencils or charcoal will produce textured fur when used on rough paper, for example. Similarly, rough paper can help you to depict the roughness of a shaggy dog, cat or horse. Pen, pencil and coloured pencils used on smooth paper will help you to create the idea of smooth textures.

You can create an illusion of coarse, dense fur with short, stubby marks and soft, downy fur or feathers with longer, light, wispy lines. Look closely at the direction in which fur, feathers, wool or hair grows. Also note where it changes over the body. For example, the fur is usually coarser on the top of an animal, with softer fur underneath. By drawing strokes in the direction of growth, your results will be credible. Never try to draw every hair, but build up hatched or scribbled marks to give a shorthand impression of the texture you are recreating.

TEXTURE

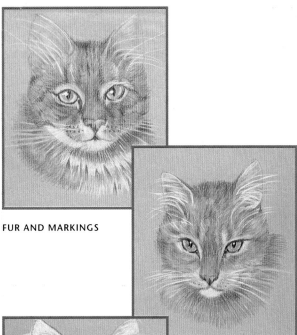

FUR AND MARKINGS

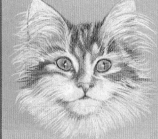

SHORT FUR

LONGER FUR

NEGATIVE SHAPES

FUR and FEATHERS You can draw effective fur with Conté sticks or coloured pencils by using two or three different shades, with hatched lines, in the direction of growth. You can do the same for feathers, but these should be rendered in clumps. Never try to show every hair or every feather; a general look is best, so begin by making light marks then darken the shaded areas. Go over any areas that don't blend smoothly from light to dark. Keep some lines close together and space others apart to build up a realistic image.

NEGATIVE SHAPES These are the spaces between the solid parts of the object you are drawing. They are important because they can help you to get proportions and angles right in your drawings. Looking at the negative shapes when composing a picture will also help to create a harmonious image. A slight shift in your position will give you different negative shapes, which could alter your picture for better or worse. When drawing, keep checking that your negative shapes are correct.

GEOMETRIC SHAPES You can eliminate the initial problem of getting an animal's body shape right by simplifying its form into various geometric shapes. These shapes may be triangles, cylinders, spheres, cones, ellipses, rectangles or cubes, depending on the animal and its position. Not only will this remove any mystery as to the complex forms of some animals, it will also help you to build up a three-dimensional shape and to recognize the effects of perspective. It's not as difficult as it might seem! Half close your eyes and view your subject as simple shapes

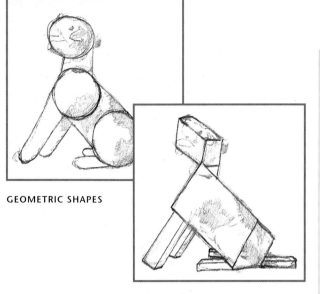

GEOMETRIC SHAPES

GEOMETRIC SHAPES

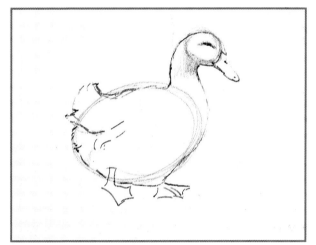

BASIC UNDERLYING STRUCTURE

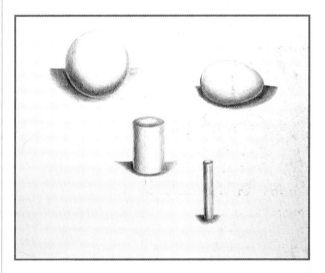

TONES ON GEOMETRIC SHAPES

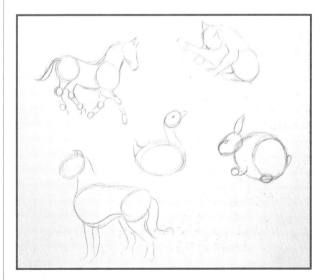

SIMPLIFIED SHAPES

only – not an animal. You can either visualize these as three-dimensional geometric forms or as simple, flat shapes upon which to build up a more realistic outline.

This practice becomes easier with use and helps the initial drawing stage enormously, not least because it establishes accurate proportions from the beginning. Also, because animals rarely stand still for long – and usually feel uncomfortable being watched closely – the simplified shapes help to structure an animal correctly with the minimum of observation if you're drawing from life.

Using this method as your basis will also help you to add tone with greater accuracy, and without being confused by more complex shapes. Notice that the lightest highlights usually appear closest to the darkest areas.

Remember that the form of an animal changes according to its position – standing, sitting, lying etc. Once you have become used to looking at animals in terms of shapes, you will find that your drawings become far more objective and straight-forward, no matter how the animal appears.

EYES All eyes are spheres in bony sockets and, as a result, they catch the light as spheres. This means that they require shading to render their curves. In nearly all animals' eyes, the inside corner is lower than the outside. Also, note the different positions of eyes from animal to animal. Horses and rodents have eyes on the sides of their heads, while cats, dogs, pigs and ducks have eyes on the front. Upper lids cover more of the eyeball than lower lids do, and lower lids often catch the light from above. Some animals, such as horses, cows and pigs, have noticeable lashes. Be sure to observe these distinctions before you draw an animal. Also note that the eyes of young animals seem to be larger, lower down the face and closer to the nose than in adults.

Always be aware of your own eye-level in relation to your subject. For example, don't draw a cat's ears from above and its eyes straight on. If your picture is looking a little odd, this could be what has happened, so keep checking your viewpoint.

NOSES and MOUTHS Study each animal's nose to ascertain how it is both shaded and attached to the mouth. There are large variations: for example, dogs' noses are usually soft and shiny, cats have little upside-down triangles, rodents have "v"-shaped noses and horses and ponies have soft noses with what looks like two black "commas" on either side. Many animals' mouths extend from their noses. Although it's nice to show an animal smiling, as they often seem to, be careful not to exaggerate this, as you may end up with a cartoon-like face.

EARS Most animals' ears emerge from a cylindrical shape, which can be seen clearly in pigs, horses and rabbits, but is concealed in many cats and dogs. (Dogs have the greatest variety of ears). Many animals can move just one ear at a time to pick up sounds. This can add a characteristic expression. As with all the features, look carefully at an animal's ears as you draw and don't assume you know what they look like!

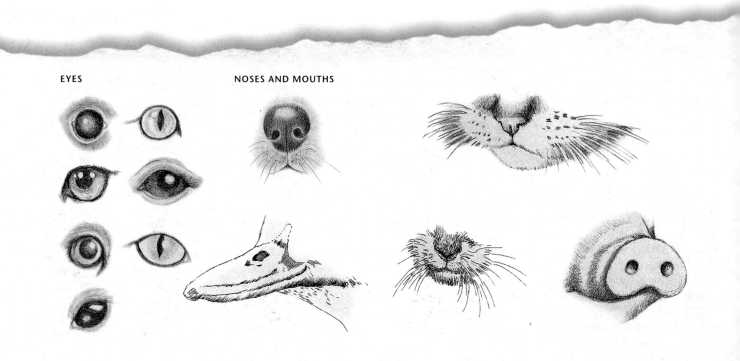

EYES

NOSES AND MOUTHS

FEET, PAWS AND HOOVES These will seem less daunting if you start by sketching them as a rough circle and add detail later. Different animals walk on different parts of their feet, and this affects the way they move or stand. Cats and dogs, for example, walk on their toes. Ducks waddle on the flat of their webbed feet. All feet reach the floor at a particular angle to the ankle. Don't ignore the feet, but don't worry about them unduly either – they will become easier to draw with practice!

PHOTOGRAPHS These provide useful references and give you the opportunity to understand more closely the details of the animals you wish to draw. You can work at your own pace from a series of snapshots taken as the animal moves or from just one image of the animal in a certain pose. They can help you to work out the deceptive shapes and distortions that happen when an animal is foreshortened. But be aware that photographs can also be misleading. As they don't reproduce images in three dimensions, perspective can appear askew and distance seem flattened.

All of the demonstrations in this book have been drawn from photographs so that you can see how to build images of animals accurately and skilfully. Generally, however, try to use both photographic references and sketches from direct observation. Keep your sketchbook handy and, whenever you get the opportunity, try to sketch animals. Notice how they hold their heads, how their spines curve and bend and how their fur lies. These rapid visual notes needn't be neat or presentable, but will help to build up your confidence and expertise. To do these sketches work quickly and don't panic. Draw only what you see and don't worry about details. Refer to your scribbles, sketches or studies when drawing a particular animal. You'll be amazed how useful a quick sketch that you drew in a minute at the park can be. The more of these sketches that you do, the more familiar with animals you'll become.

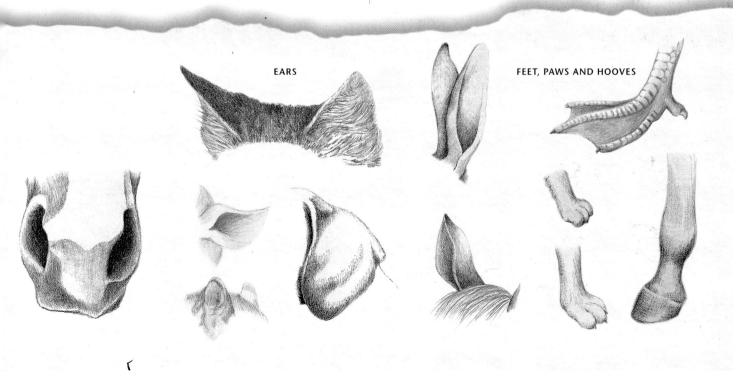

EARS

FEET, PAWS AND HOOVES

Demonstration **1**

Basic Cat *Graphite pencils or sticks*

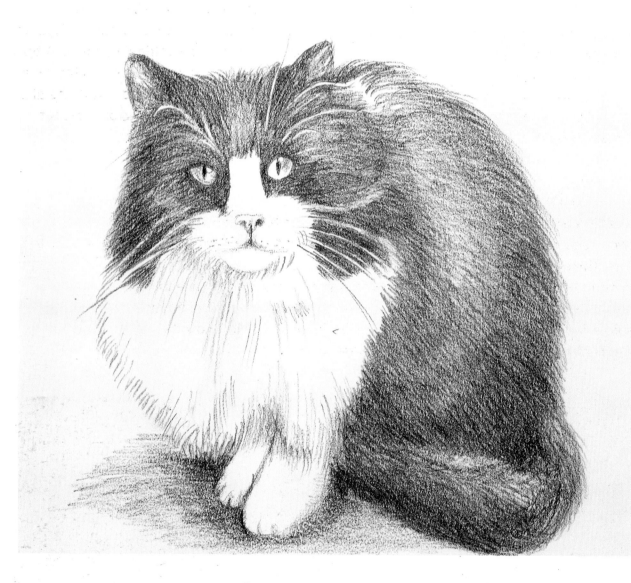

A good, basic principle when drawing an animal is to begin by looking at the whole shape. If you can render the basic form accurately you will be able to add detail convincingly too. Know before you even begin to draw what proportions (approximately) you will be working with.

Graphite pencils are easy to use and can produce a range of versatile marks as they move quite fluidly across the paper.

They are also easily erased, which makes them ideal for beginners. Graphite sticks are similar to pencils, but tend to be heavier and more brittle. Thick sticks are best for broad, loose drawings while thin sticks work well for more detailed work.

Try them out in a sketchbook, just making a few marks to begin with, to get used to the feel of them. Keep your pencil or stick sharp for details such as whiskers, and use the stick on its side for broader areas of tone. I have only concentrated on the cat for this first demonstration but, if you find you are doing quite well, you could also include the contrasting lines and tones of the roof tiles to make a slightly more intriguing image. A tip if you do this – make the details on the cat a little sharper and be fairly loose with the tiles to just give a general impression – the cat should remain the focus.

Subject

A cat is a good subject for beginners. The face can be broken down into two circles, with a small triangle for the nose and two larger triangles for the ears. The eyes are ovals that rest in the head circle. By observing a cat's face in terms of these basic shapes, you eliminate any anxiety about where to begin. Before you start drawing, however, think about composition. A tiny animal in the centre of the paper will diminish its effect, while an overly large animal will appear to "fall off" the edges of the paper.

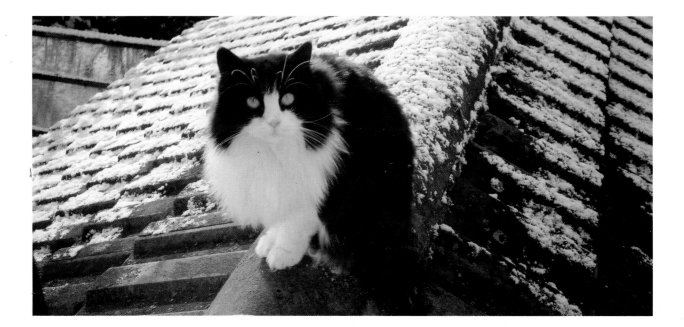

Materials

2B and 4B graphite pencils or sticks

Sheet of smooth cartridge (drawing) paper 297 x 210mm (11¾ x 8¼in)

Plastic eraser

Kneaded eraser

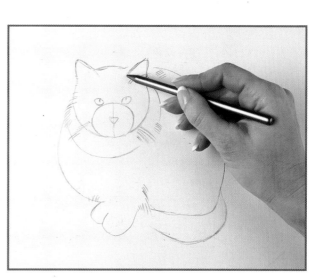

1 Study the photograph of the cat as a series of simple shapes. The face is composed of two circles, and behind the head you can see the curved shapes that begin to form the body. Transfer these shapes to your paper using the 2B graphite pencil. Hold the pencil fairly far back and draw lightly, as you do not want these initial guidelines to show in the finished drawing. Make sure that your cat is large enough on the paper to appear significant.

2 Still seeing the cat as a series of shapes, add a small triangle for the nose and begin to make adjustments to the initial guidelines. For example, notice that the ears begin on the forehead, not on the top of the head, and that they curve slightly. A photograph is a particularly good reference for seeing exactly how an animal's features fit together – where the nose meets the mouth and the distance between the eyes and top of the head, for example. Keep checking the proportions as you go.

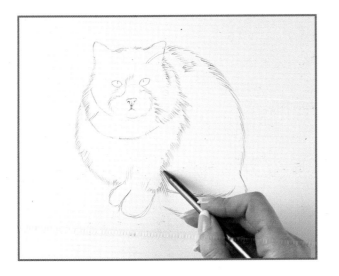

3 Although head shape and proportion varies from one cat to another, there are a few common characteristics that are useful. For example, the eyes are always roughly halfway down the face and slant upwards at the outer edges. Cats' cheekbones also slant upwards at the outer edge and the fur on the nose grows down. Soften the nose on your drawing and add an upside-down "Y" for the mouth. Begin to add little lines on the body to indicate fur. Use the plastic eraser to remove your guidelines as you add more detail.

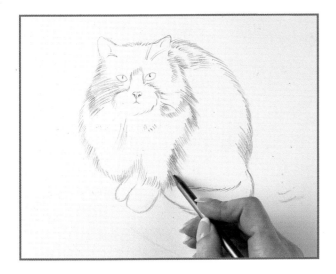

4 To create the impression of fluffiness keep your 2B pencil well sharpened and use its point to mark on lines in the direction of growth. You can create the look of soft fur without drawing each hair individually. Double-check the cat's proportions in the photograph by looking at the areas around and between the features. For example, the distance between the eyes should be about the same as the distance from the top of the nose to eye level.

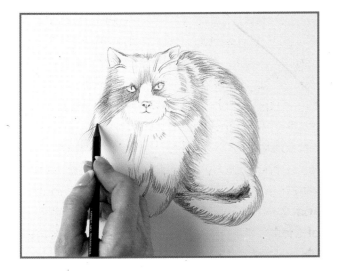

5 Using the 4B graphite pencil, continue adding strokes of "fur". Add some detail to the features and establish the darkest tones by drawing more strokes in those areas. For each whisker, place the pencil on the paper at the point at which the whisker emerges and flick in the direction of growth. This creates a natural-looking, tapered effect. When trying to ascertain tone, half close your eyes as you draw to see if you have created enough contrast in lights and darks. Add darker tones if necessary.

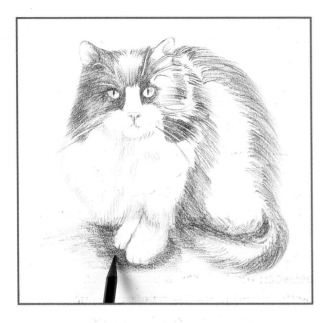

6 Still with the 4B graphite pencil, add the darkest tones to the ground beneath the cat (a subtle "fading away" will give a softer final picture). This adds solidity to the picture and stops it looking as if the cat is floating. Now add subtle detail, such as the shading on the eyes, leaving small circular areas of paper to show through for highlights. Also "feather" in the fur in the ears, the whiskers and on the paws. Continue to add layers of hatching strokes on the face and body, building up a thick density of "fur". Use firmer pressure for the darkest areas, such as around the tail.

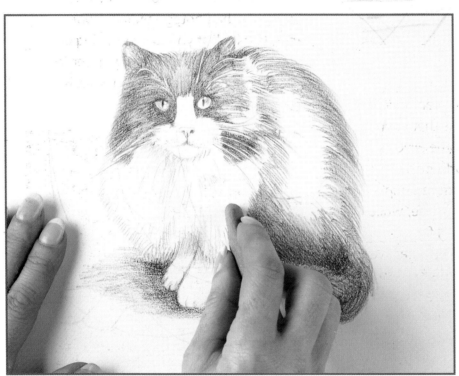

7 Add lighter, irregular lines for the shadows in the white fur of the chest. Then, using the kneaded eraser, squash it into a manageable shape and "lift out" the whitest areas. Finally, using more strokes for the fur, continue to cover the body, making sure that the darker areas are covered with darker graphite marks. Ensure too, that the whiskers stand out a little. If you have missed this, knead the eraser into a pointed shape and lift out colour where you need the white of the paper to show through. Add a little light tone around the mouth and nose area and shade the ground a bit more until the cat looks comfortable sitting on it!

Artist's tip
If you find that your drawings are constantly smudged with grubby graphite, pencil or charcoal marks, put a piece of scrap paper under your drawing hand as you work.

TRY A DIFFERENT ...

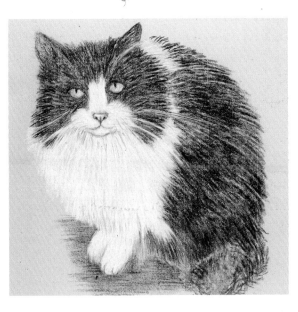

... MEDIUM

Charcoal and chalk are instantaneous and pliable, which means that your drawing will begin to come alive as soon as you put the marks down.
A dark beige, slightly textured paper provides an effective mid-tone, while the white chalk works well for highlights. To be at its most effective, charcoal needs to be used freely, so work in a loose manner. Use the same measuring techniques as in the main demonstration drawing and then layer on strokes of charcoal to indicate fur. Keep your lines light but varied in intensity and density, blowing excess charcoal and chalk dust off the paper as you go. Wipe any mistakes lightly with a clean rag or some kitchen paper and then work over them. Spray your finished picture with fixative to preserve it.

... IMAGE

Try drawing the head of this cat. Note the shapes of the eyes and where the light falls. With light pressure, shade the soft areas beneath the nose, under the chin and around the ears. If you still don't feel confident about proportion, physically measure the distances between the features, multiply them by three and mark the points on your paper. Then join the dots! Remember to look at the photograph more often than you look at your own drawing or you will begin to draw what you see in your imagination, rather than what is really there.

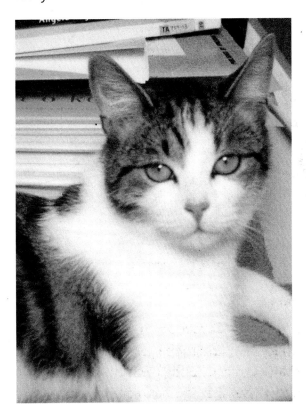

Demonstration 2

Pig *Pencil*

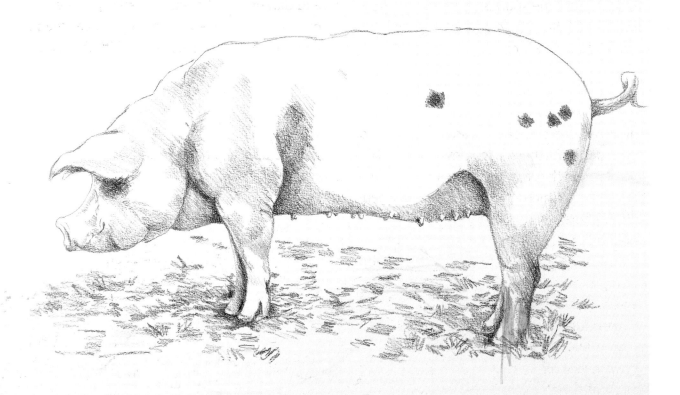

Pigs are enduringly popular. Greetings cards are frequently adorned with them and children grow up with piggybanks and stories of cute little pig characters. And so our affection develops. Images of happy, plump, pink creatures on the farm may or may not be wholly accurate, but pigs are a good subject to draw nevertheless! They are made up of simple, solid shapes, domed foreheads, triangular ears and smiley mouths. It might sound surprising that the underlying structure of a pig's rounded

body is rectangular and, as with most animals, it can be divided into three manageable shapes. The first is between the neck and shoulders, the second between the shoulders and belly and the third the animal's hindquarters. Depending on the angle from which you see the animal, these shapes will change slightly. If you get used to looking for the shapes at the start of your drawing, it will help you to draw the whole form with greater accuracy.

Drawing the basic underlying shapes first of all is helpful when drawing a straight-forward view, but even more helpful when you have an unusual or foreshortened viewpoint. Foreshortening is the perspective effect which makes things appear larger the nearer they are.

Pencils, unlike pens, can vary the lightness and darkness of the line according to the pressure and stroke you use. If you over-shade your picture, use an eraser to "lift" the darks.

Subject

This pig is in a straightforward position – completely in profile. Even so, the legs that are furthest from view are foreshortened and so appear smaller than the two legs that are closest to us. Try always to be aware of the illusions of perspective, which give line drawings a sense of depth and distance. The lighting here is also uncomplicated; it comes mainly from above, making the darkest areas of the image underneath the belly and legs. As you draw, keep your lines light and sketchy to prevent the classic image from looking like a cartoon character.

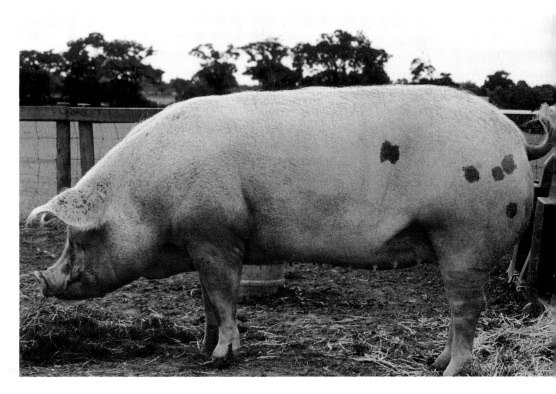

Materials

2B pencil

Sheet of slightly textured cartridge (drawing) paper 420 x 297mm (16½ x 11¾in)

Plastic eraser

1 Drawing the pig in the centre of your paper will give a balanced overall image. The pig in profile is a strong, straightforward image, with little detail on show. Even the eye is simply a smudge under the flapping ears. Visualize this pig as simple, geometric shapes. You don't have to draw the shapes, but be aware of the way in which you could simplify the outline. For example, the main body is box-like, the legs are cyclindrical and the nose is cone shaped. This will help you to draw the pig as a solid form and to understand the tones and perspective more easily.

2 Always try to work out comparisons between different parts of the animal to get the proportions right. For example, there are four head lengths in this pig's body. Work out other proportions, such as the size of its ears in comparison to its nose, the distance between its front and back legs and the depth of its body. If you drew the geometric shapes as discussed in the first step, roughly soften the shapes by drawing around the outline with broken curved lines and erase the geometric guidelines.

3 Add a little curve for the pig's tail and begin to "soften" the guidelines. This is where you begin to look more at the photograph and less at your drawing. This is the best way to draw from observation and you should spend about 60 per cent of the time looking and 40 per cent drawing. Even draw *while* you look at the photograph – lightly so you can adjust it if need be – this way you will draw what you see rather than what is in your imagination.

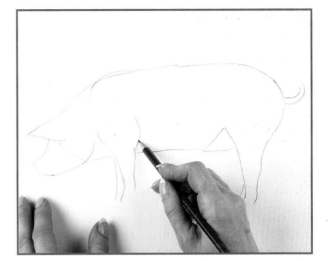

4 Continue to adjust your guidelines with broken, more curved, lines. For example, the ears are not such a straight triangle shape, but tend to curve into their point and flop slightly over the face. Shape the nearest ear and nose carefully, indenting the end of the snout and giving the ear its floppy look. Watch the negative shapes around the pig's face as you work. When you are satisfied with your softer, curved shapes, erase the rest of any original guidelines.

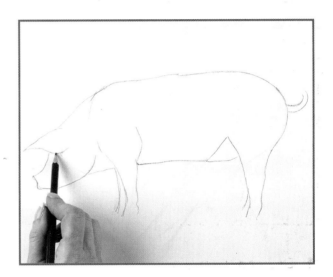

5 Half close your eyes and try to see where the darkest tones are in the photograph – they appear to be mainly around the front legs and under the ears – and shade a little around those areas. Don't worry about being too neat – a little scribble in the right places is all you need for now. Scribble three patches on the pig's rump and shade where the tail meets the main body. Shape the legs a little more carefully – the front legs have an "elbow" against the body and all four legs have ankles that protrude slightly towards the rear.

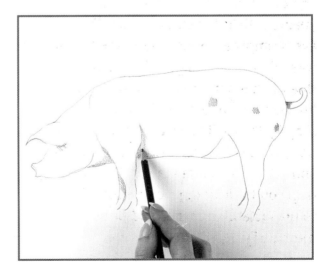

6 Draw in the little bit of ear furthest from view. Begin to soften the toned areas by shading gently up and down or in small circles. Shade the freckle-like patches on the pig's back more carefully and draw a line curving upwards for the mouth. Start to draw the feet, with their upside-down "V"-shaped trotters, bearing in mind that they are not clear in this picture, so scribble a bit around them to indicate straw on the ground. Darken a small area under the chin and back leg.

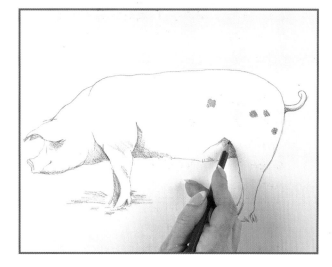

Artist's tip

Composition is about visually balancing all the elements within your picture. If you don't like what you see in front of you, change it. Try out different compositions with "thumbnail" sketches to see what works best. This pig, for example, fills the space well and draws the viewer's eyes into and around the picture.

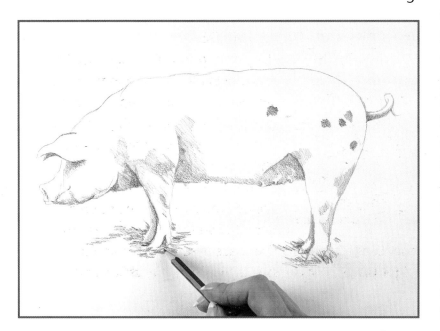

7 Using slightly heavier pencil pressure, scribble under the chin, pressing harder in the "corners", that is by the face and by the body. Go over the tonal marks on the tail, on the patches near the tail, on the split of the front foot and on the front rear leg. Using light pressure, shade in patches under the belly and on the legs. Keeping your pencil sharp, draw some tiny "U" shapes to indicate about eight to ten teats. Make sure that the legs are shaped correctly – look for the curves and darkest tones. Now is the time to add small details in order to give the picture life and to make it look more three-dimensional. Sharpen your pencil and add darker tones – just a few – on one side of the teats, on the area where the eye is, under the nose and mouth, on the back ear and under the back leg. Finally, scribble horizontally and vertically around the feet, to anchor the pig on the ground.

TRY A DIFFERENT ...

... MEDIUM

This drawing was created with Conté sticks. As you can see, it is rather like a sketch with just the main outlines and tones capturing the image. Use textured paper with Conté sticks, charcoal, chalk or pastel. The "tooth" of the paper "grabs" the powder of chalk-based materials. Keep your eye on the

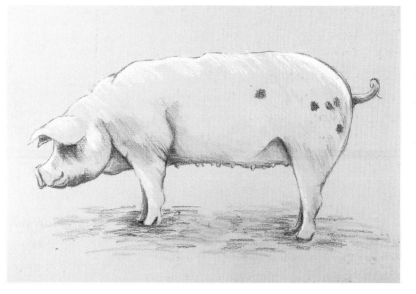

photograph of the pig and break it up into sections in your mind's eye: the head, the shoulders and front legs, the torso and hindquarters. Using broken lines, sketch the general outline and legs. Don't worry about details until you've established the correct proportions. Use a restricted palette, such as sepia, grey, black, white and/or brown. You can use a torchon to blend some of the darker toned areas under the legs, tail and ears. Spray the finished picture lightly with fixative.

... IMAGE

Try drawing this! This pig's face has more details on show and the nose appears more turned up. You can get a feel of the animal's personality – curious and contented. As with the drawing in the main demonstration, you don't need to include too much detail, but make sure that you get the proportions right before you begin to add tone. Look at the negative space around the head and check that the curves are in the right places. Use the side of your pencil to shade and mark on a few wisps of straw.

Demonstration 3

Rabbit *Pen and ink*

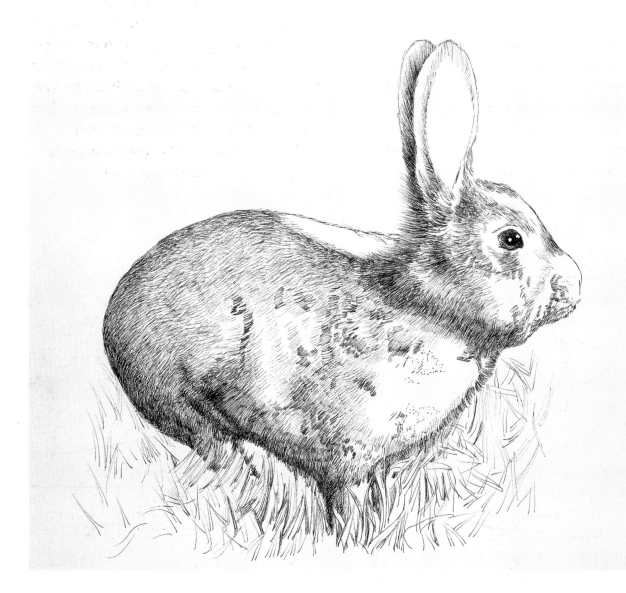

Although this pen drawing seems detailed at first glance, it is actually just a few simple shapes with a high level of hatching. Pen and ink drawings can be as detailed as you wish.

Smooth paper allows you more control and a fine nib gives you the flexibility to build up a more intricate drawing. Because pen can't be erased, it makes sense for beginners to begin

with a light pencil outline, which can easily be adjusted. Then the pen can be used to create the impression of different textures and tones. Short hatching strokes produce the appearance of soft fur, especially when they're layered close together for darker toned areas and are fairly sparse for the lighter parts of the rabbit. Remember that a finished drawing does not have to be over-detailed to be effective.

You can build up tones with a looser pen and ink technique, by scribbling lightly over the outline and around the darker tonal areas rather than hatching and cross-hatching. Although this can be an effective technique, it is more difficult to do than hatching or cross-hatching but it is worth trying out as it can give your animals vigour and movement. This won't give such a realistic impression of fur, but gives your pictures a vibrant texture. Traditional hatching uses a series of slanting lines, but if you want to give the rabbit slightly longer, fluffier fur, make your lines longer and even curve them a bit.

Subject

This rabbit, with its soft, furry coat, small nose and large ears, gives many of us instant memories of childhood. The shape is not particularly distinctive, neither are there too many obvious tones. So the drawing needs to be built up with texture. Pen is ideal for this, as just a few dashes and dots will create an effective appearance. When drawing other rabbits, be aware that different species have different ears and tails and will possibly also have different fur, so lengths of hatched strokes will need to be adjusted accordingly. It is worth studying the Old Masters, such as Albrecht Dürer, for the way in which they depict fur.

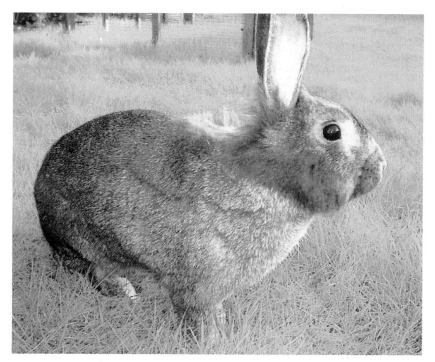

Materials

2B pencil

Technical pen with fine nib (.01)

Sheet of smooth cartridge (drawing) paper 420 x 297mm (16½ x 11¾in)

Plastic eraser

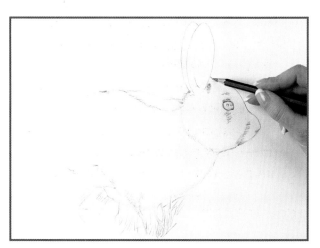

1 Study the animal as objectively as you can, both from within (the positive shapes) and without (the negative shapes). This rabbit is simply a series of curves and ovals. Mark these lightly on your paper using the 2B pencil. Check that you have enough space around the animal to draw a viewer's eyes into the picture, but not too much space to make the rabbit appear insignificant. We are all familiar with rabbits in cartoons and it can be a temptation to draw what we think a rabbit looks like, but resist if you can!

2 Still using the 2B pencil, go over your basic guidelines and adjust them to follow the photograph. Develop the curve of the spine and the length of the ears and check proportions and relative sizes. For example, the head fits into the body about three times, and the distance from the mouth to the top of the head is the same as the length of the ears. You should aim for a "light touch" drawing that reveals the animal's character and texture, without worrying too much about detail. Don't press too hard, as these pencil lines will be erased later.

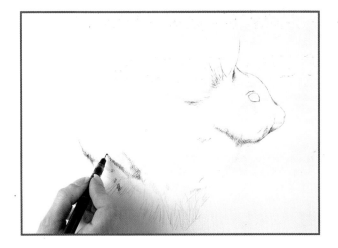

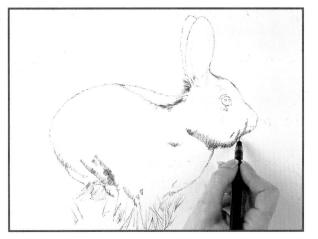

3 As soon as you feel confident with the outline, pick up the pen. It is a good idea to try out the flow of your pen's ink on a spare sheet of paper before you start. Begin to hatch short lines around the face and back legs. Draw your strokes in the direction of fur growth. Don't press too hard and don't worry about fine details yet. The rabbit looks as if it's poised for flight, which is characteristic of most rabbits, but makes it a little squashed around the back leg area.

4 Continue to work mainly around the outline, following the photograph. For example, draw the fur flatter on the back, but with longer lines behind the ears. Technical pens can't show variation in tone or width of line, but hatching and stippling, although time-consuming, can be used to create a soft, expressive effect.

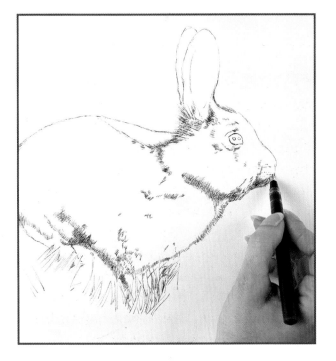

5 Hold the pen fairly far back and lightly sketch short lines on and around the entire body. Use a little cross-hatching under the chin and ears to give the impression of darker shadow but don't make this too dense, as you need to see some of the paper between the strokes to make the fur convincing. The closer you place your hatched lines, the darker that particular area will be. Ensuring that the ink is dry, erase any pencil guidelines and continue to work over the body with the light hatched strokes. Aim for a light, fairly loose touch. You should work over the whole animal at once, but try to ensure that your marks are not exactly the same weight and intensity all over.

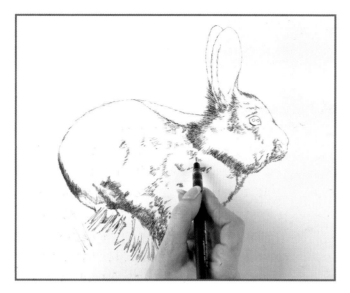

6 Build up the fur by working all over the rabbit and concentrating on the darker areas. It is not too late at this stage to change some of the outlines if you're not happy with them, just persevere with the hatching lines. Most rabbits have similar soft fur and the best way to describe that texture is with shorter hatched lines in the darkest areas. If you feel that you are applying too much pressure, practise in a sketchbook or on a separate sheet of paper until you feel confident with this technique.

Artist's tip

Be patient when building up texture. The procedure of hatching, cross-hatching and stippling may seem tedious and time-consuming, but the texture will start to appear and improve as you keep going.

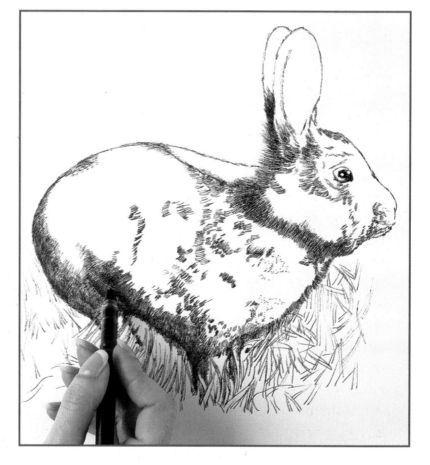

7 Hatch longer lines in varying lengths and directions to indicate some grass. This really is just a suggestion and little detail is required. You need stippling on some parts of the rabbit, such as in the eyes and below the nose for whiskers. Make sure that the darkest tones on the photograph are also dark on your picture. Once you've started, it can be tempting to carry on hatching the animal solidly all over, but the danger here is that you will end up with a flat picture, so make sure that you allow the paper to show through for highlights.

TRY A DIFFERENT ...

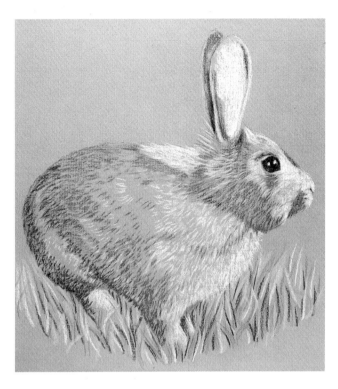

... IMAGE

This rabbit is a mixture of brown and grey, so if you use a coloured medium when you draw it, blend light grey and light brown in hatched strokes, adding darker brown around the deeper toned areas. Vary your lines and try to work across the entire animal at once. Show the contrast in texture of the fur and eyes with different marks – little sketchy lines for the fur and smooth shading for the eyes. (Always leave the bright white highlight on the eyes to give the impression of shine.) Remember that rabbits are renowned for their softness so your marks should be light to reflect this.

... MEDIUM

Drawing the same rabbit in pastel pencils is quick and effective. The fur lends itself to the "soft" finish of pastel pencils and whether you use a torchon to blend or you layer colours over each other, results are immediate and satisfying. Use a coloured, textured paper and sketch the first outlines in pencil, working over them with layers of colour. Pastel pencils can be worked over each other to adjust any mistakes and layers of colours add intensity and depth to a picture. For the background, use a dark pastel pencil to indicate some ground beneath the rabbit, "anchoring" it on the paper. Try smoothing this background with a torchon to contrast with the fur.

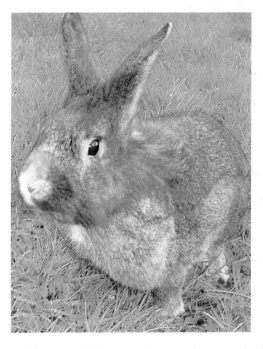

Demonstration 4

Ducks *Charcoal and chalk*

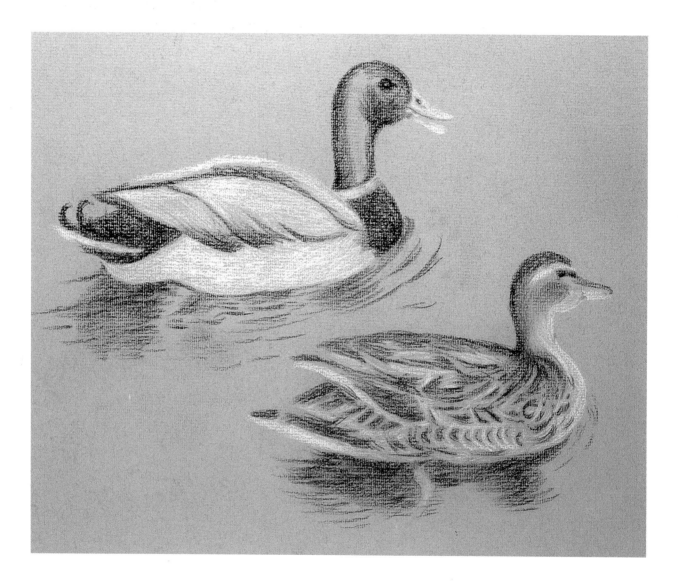

It will be a rare occasion that you spot a stationary duck, but whether waddling about on dry land or paddling across water, ducks are excellent subjects to draw. Their outlines and markings are simple but distinctive and just a few lines can give a realistic impression of the duck's characteristic shape. Charcoal and chalk – man's oldest drawing materials – both give immediate results and respond to gentle pressure. Thin sticks can be used to

effect for the more delicate duck feathers, while thicker sticks or compressed charcoal will work well to build up dense tonal areas. They can also smudge and become messy, however. Charcoal pencils will keep your hands cleaner and can be sharpened without much risk of breakage, but they usually have a harder texture. To an extent, most charcoal and chalk can be erased, smudged for effect or layered. The fine, powdery quality of white chalk contrasts well with the coarse texture of the charcoal and both should be used with a bolder, freer approach than pencil or pen.

Subject

Ducks have an oily film on their feathers, which keeps their bodies dry when they swim and maintains their streamlined shape. Even when not swimming, they like to dip their heads into water and to throw it over their backs. When drawing these two ducks, use the ripples as an extension of their shapes, which helps to show movement. Notice how the two shapes echo each other and how the ripples link their negative shapes, making two separate subjects form one complete image. If you use a textured paper, the lines you make will be rough and expressive, which will also enhance the end result.

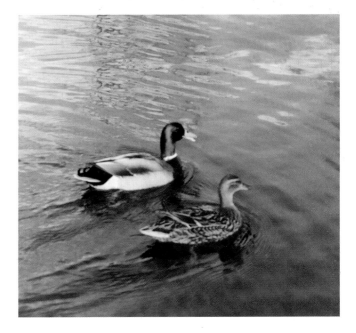

Materials

Fine willow charcoal

White chalk

Light blue-grey textured pastel paper 420 x 297mm (16½ x 11¾in)

Kneaded eraser

Fixative

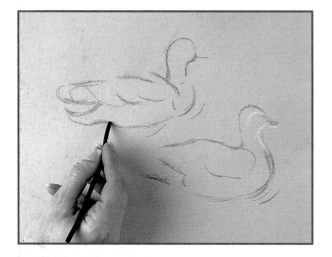

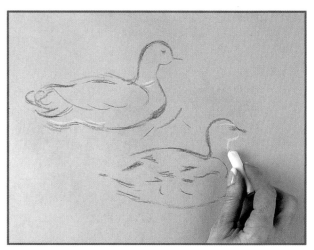

1 The light, dusky blue tint of the paper complements the black and white of the charcoal and chalk. Visualize the image on the paper by studying the photograph and keep the outline of the ducks in your mind as you transfer your gaze to the paper. Then draw the ducks in charcoal, beginning with a few curved marks. Unless you're using compressed charcoal, you can erase mistakes if you press lightly. Use a light touch and begin adding some white on the front duck's head.

2 A duck's basic shape is fairly simple – a small oval or egg shape for the head and a larger oval or egg shape for the body. The neck – from the duck's back to the top of the head – is like an elongated "S". Lightly mark on some more curves to indicate both outline and texture. Add more strokes of white to clarify some areas of white feathers and to indicate highlights. The beak emerges from the head at a right angle and the head fits into the main body (excluding the neck) approximately four and a half times.

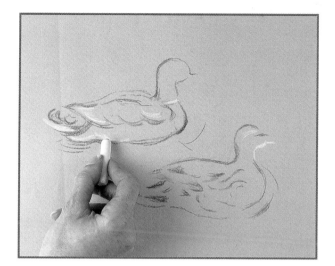

3 Alternating between the chalk and the charcoal, continue to draw the outlines of the ducks (using broken lines) and start to draw feathers on the bodies. "Firm up" some of the white curved marks, but try to keep the balance across both ducks – don't concentrate on any one particular area.

4 Keep using the charcoal and chalk in a sketchy way in order to give the impression of feathers. Note how the base of each duck curves on the water and the water ripples echo these curves. Sketch some more curves and dashes on the ducks' bodies to indicate more feathers and add strokes of charcoal to describe some of the darker tones.

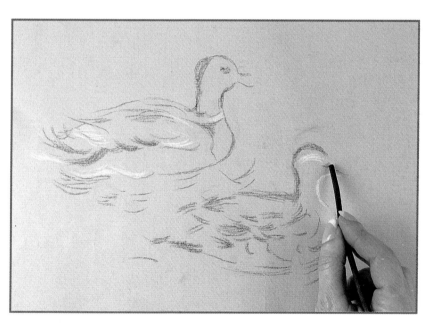

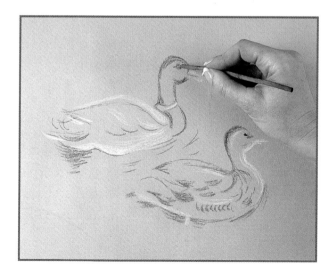

5 Keep your touch light, but go over any areas that need a bit more detail and build up definition in these areas. Bear in mind the ducks' basic shapes as you work and keep referring back to the photograph to ensure that you are drawing what you see, not what you think ducks look like. Start to build up some reflections in the water by using the charcoal on its side. Include some definite curves as well as blended shapes. Mark on the eyes.

6 Add more white chalk over the areas where there are white feathers. Make these marks a mixture of long and short curved lines to describe the rough-smooth texture and to make some lighter parts of the ducks appear to come forward. Don't overdo any of the marks, but leave plenty of paper showing through. Now you should start to establish some tone on the ducks' cheeks as well as a few specific markings on their bodies. Notice where you can just about make out their legs under the water. This should not be a detailed, tonal drawing, but more of a line drawing. Shade the darkest areas with the charcoal – the front of the furthest duck from view, its back feathers and both ducks' necks – to give the impression of depth. Use the white chalk to emphasize highlights, to pick out white markings and for the beaks. Add these details carefully, following the contours of the ducks. When you are happy with your picture, spray it lightly with fixative to preserve it.

Artist's tip
Charcoal and chalk can be blended together with a torchon or stump. Make your marks first, then rub the torchon across the surface to blend. You can also blend chalk and charcoal by applying them in layers to create a soft grey tone.

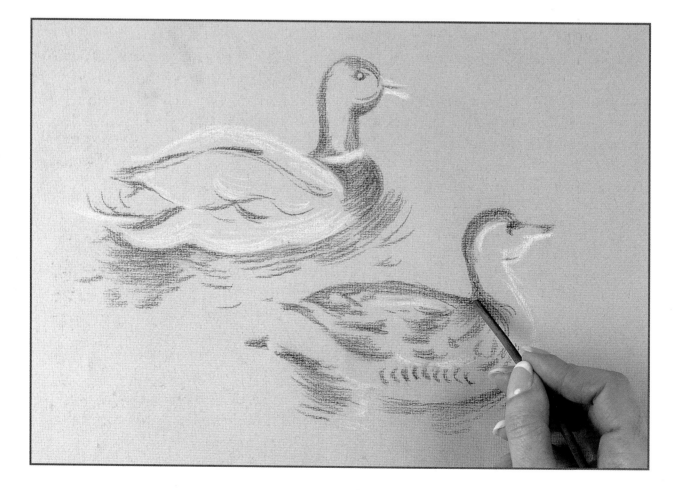

TRY A DIFFERENT ...

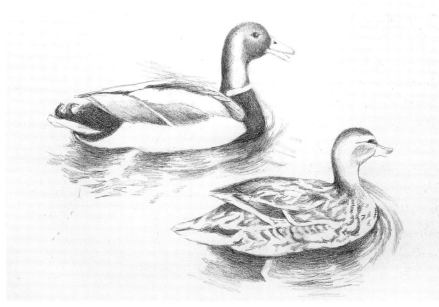

... MEDIUM

Draw the same image in a range of sharp graphite pencils on good-quality paper. Use a 2B pencil to capture the basic shapes and then continue with the same pencil to define the darker feathers and the ripples in the water. Keep your wrist flexible and hold the pencil fairly far back. Soft pencils allow good flexibility of line and tone. Use a 4B pencil to shade the bodies of the ducks, the necks, heads and faces. Keep the pencil sharp and fill out the ripples and reflections around the ducks. As with all drawings, keep an eye on the negative shapes and bear in mind what the completed composition will look like.

... IMAGE

Try drawing these ducks with charcoal or graphite sticks for a quick sketch or with coloured pencils or pen and ink if you want to show more detail. Coloured pencils or pastel pencils can be used with a variety of techniques – from hatching and cross-hatching to smooth rendering. Layering colours will give a rich finish, but keep a light touch. The composition works well, with a certain amount of background and the two ducks in the foreground almost reflecting each other's stance.

Demonstration 5

Squirrel *Pastel pencils*

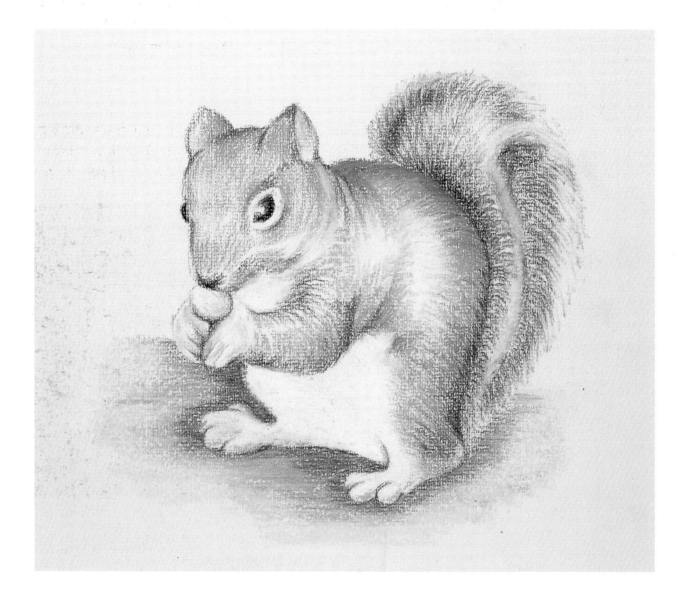

Pastel pencils allow you to be expressive and to work quite quickly. Just a few strokes can create effective-looking texture and there are many ways of blending colours on the paper's surface. The best way to use them for animal drawing is for hatched lines drawn in the direction of fur growth. Layer dark over light colours or vice versa to create

interesting depths of tone and texture. Although pastel pencils come in a variety of colours, restrict yourself to just a few for your first animal drawings and keep your style sketchy and light. The colours can be smoothed with a torchon if you prefer this look. Be aware, however, that if you do this too much, you could lose the furry appearance that is achieved with broken lines. Remember that this medium is difficult to erase although you can layer colours to "blot out" mistakes in some cases.

Subject

This is a classic squirrel pose. Crouching on its sturdy back legs, it is eating a nut and watching us cautiously. Although it is a grey squirrel, it has a lot of brownish-red in its colouring. Show the differences between the dark, bright eyes and the bushy tail by using the pastel pencils in different ways – more carefully for the eyes with looser lines in the direction of growth for the tail. Keep any rubbing or smudging to a minimum and try to work across the whole animal, rather than in tight little areas. Allow the paper to show through for mid to light tones. You can use pastel pencils on plain white paper, but they are more effective when used on coloured paper with a texture or "tooth".

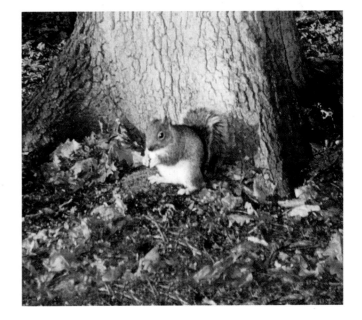

Materials

2B pencil

Pastel pencils in light and dark grey, white, ginger/orange, sepia and ochre

Sheet of tinted pastel paper 400 x 300mm (16 x 12in)

Fixative

Plastic eraser

Torchon (optional)

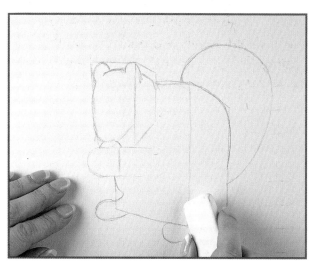

1 First look at the photograph and think about your composition. Where will you position the squirrel? I positioned the squirrel slightly to the right of the paper as you look at it, giving the viewer's eye a chance to roam around the picture. To start with, try to envisage the squirrel as simple geometric shapes. The body, head and paws become boxes and the tail a simple, rounded shape.

2 Begin drawing the proper outline of the squirrel using the 2B pencil. Study everything – for example, the space between the ears, the size of the feet, and the height of the animal when compared to its tail. Leave nothing to your imagination, but keep looking at the photograph as you draw. As you become satisfied with your shapes, you can erase the geometric guidelines.

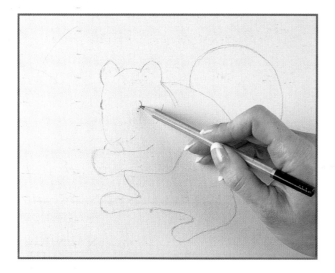

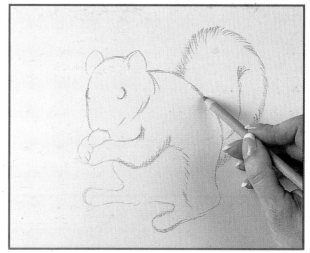

3 Keep comparing sizes across the body. Note that part of the squirrel's front leg is parallel to part of its back and that the length from the top of the head to the nose is almost the same as from the paw to the elbow. This is the measuring stage – don't worry about details yet, but mark on the position of the eyes and the nut between the paws and the mouth in 2B pencil.

4 Using the ginger-coloured pastel pencil and making broken, sketchy lines, start building up the colour around the lines you have drawn, studying the photograph at the same time to ensure that you modify your lines. For example, the bushy tail needs to look as if it's made of fluffy fur and is not simply a solid mass. Unless you've seen a squirrel at close hand, you might be surprised to know that the bushy tail is not thick and dense, but fine and wispy – almost transparent. Begin to mark on some creases around the neck and cheeks, and start to shape the ears.

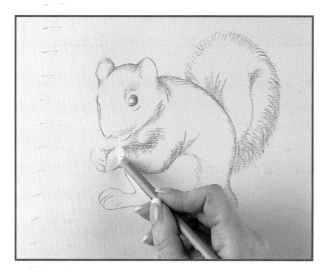

5 Work over the entire squirrel, using the same broken, sketchy lines to indicate the direction of the fur. See where the tail bends and add the curved line there. With the same pastel pencil, shade the front legs to look like fur. Define and shade round the ears and on the top of the head, give the tail more bushiness and add some colour to the eye, leaving a small area for highlight. With the white pastel pencil, start to add highlights where you see them, such as on the eye, paws and belly.

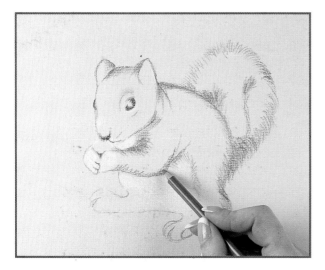

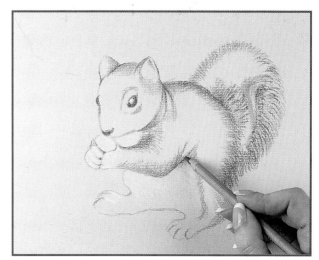

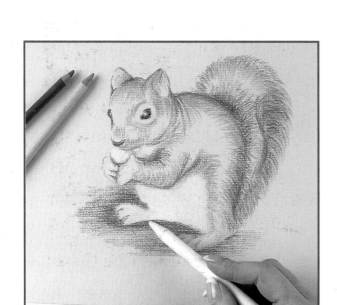

6 Carrying on in white, shade lightly across the front of the squirrel, on the paws and around the eyes. You only need to touch the paper lightly with the pastel pencil, as the chalk will catch on the tooth of the paper. As you will have discovered by this stage of the drawing, pastel pencil can be used like charcoal, but it gives brighter, lighter results. With the dark grey pastel pencil darken some areas such as the eyes, nose, front legs and the base of the tail.

7 Continuing with the dark grey, use curved stripes to shape the tail and pick out some of the fur, remembering not to make this too dense. Keep the pastel pencil sharp and make the stripes with the point of the tip. When you add smoother tones to the back of the squirrel you can use the side of the pastel point, but for the longer fur curved hatching lines are best. Use the sepia pastel for folds, such as under the leg and on the neck. Use the light grey pastel under the ear, around the neck and on the tail.

8 Use the ochre pastel in horizontal lines to shade under the squirrel, going over the shaded areas near the feet with dark grey. This has the effect of anchoring the squirrel to the ground. Alternate white, light grey and ginger pastels to complete the fur. Use the torchon to blend and soften the ground area. To finish, use a sharp sepia pastel pencil to strengthen the deepest tones, around the head, in the tail and around the front legs. On the head, body and tail, layer the light grey pastel you've already put down with ochre and sepia.

TRY A DIFFERENT ...

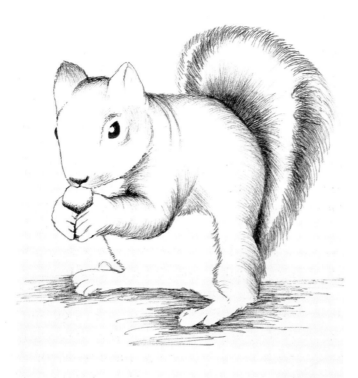

... MEDIUM

To draw the same squirrel in pen and ink, start with a pencil outline to ensure that the proportions are right. Then take your dip pen (with a narrow nib) and black ink. Keep some kitchen paper handy to wipe off any excess ink from the nib. Use the pen lightly so you don't scratch the paper and use light hatching lines or stippling to create the soft effects of the fur. You don't need to cover the whole of the squirrel in ink; just the darkest toned areas. Use long, curved strokes for the longer hair on the tail and shorter strokes for the shorter fur on the body.

... IMAGE

Squirrels are fast movers, so studying photographs can be useful. They are charming little animals and, by drawing them in a range of poses, you will learn more about their anatomy and character. Whenever you get the chance, watch how they move and how they sit and rest. Note that the round eyes are very dark and always have a white dot of highlight in them. Legs and feet can be tricky to draw accurately, so study them as closely as you can.

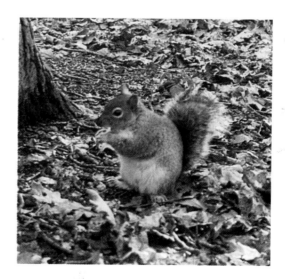

Demonstration 6

Cat *Pencil*

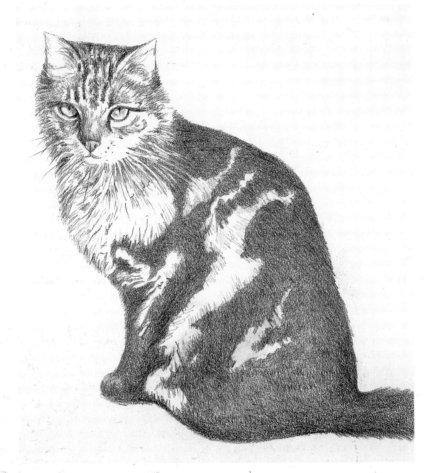

Cats are quite calming to watch except, of course, if you're trying to draw them – then it can become frustrating when they don't keep still! Try to draw from life as well as from photographs if you can, in order to enhance your proficiency and understanding of animals. As you can see, this cat drawing is more detailed than Demonstration 1 (see page 18). If you've followed the book so far, your dexterity will certainly be sufficient to achieve this finish and, in actual fact, it is quite deceptive as most of the work involves simple colouring. The main body of the cat consists of dark and medium patches, which can be rendered accurately using a range of soft pencils.

The lighting on this cat – as with all drawings – determines the atmosphere of the picture. One of the advantages of using a photographic reference is that the lighting remains the same. Here, the light is coming from the front left, which gives strong shadows and highlights. Don't see the shadows simply as dark, flat surfaces, but notice how they curve around the cat, darker in some places and lighter in others. (Usually darker at the curved areas furthest away from the light.) Light and shade describes the texture, markings and sheen of the cat's coat. Most of all, though, it makes the cat look three-dimensional, so never be afraid to make your tones really contrasting.

Subject

This tabby has a dense, thick coat and well-defined markings. If you have access to any cats, watch them objectively to become familiar with their basic shapes and draw them over and over again. Just a few sketches indicating the curve of the spine to the tail will be enough to begin with. Once you've become more familiar with outlines, balance and pose, you can build up your fur-creating abilities! Do this by establishing shapes in the markings and plotting them like a map on the cat's body using varied marks.

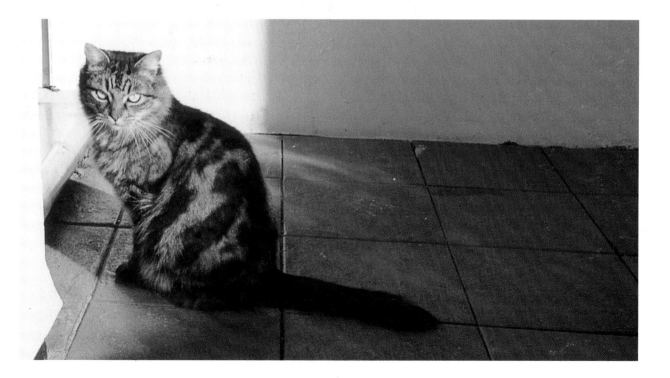

Materials

2B, 4B and 6B pencils

*Sheet of lightly textured
cartridge (drawing) paper
420 x 297mm (16½ x 11¾in)*

Kneaded eraser

1 Visualize the general shape of the cat on the paper. The face is made up of circles and triangles, while the body is more box-like with the head at the top corner. Use the 2B pencil to mark the basic geometric shapes. Check proportions – for example, the head fits into the body four times – but do not worry about details at this stage. Lightly position the cat's features.

2 Draw within your initial guidelines, picking out the shape of the cat with curved, broken lines. Adjust proportions and angles as you go and, only when you are happy with the outlines, begin to erase the initial geometric guides. Start to link the ears to the head by bringing their edges down on the forehead and shape the nose and eyes, so that they begin to look more cat-like.

3 Still using the 2B pencil, draw short lines to build up the markings. Keep your eye on the negative shapes around the cat as well. Don't worry too much about detail at this stage, but check angles, lines and proportions. Shape the eyes and ears lightly, but don't dwell on this too much. Keep moving over the whole animal, scribbling here and there in order to keep the drawing balanced. Rub out any remaining guidelines and softly add a few dashes to indicate whiskers.

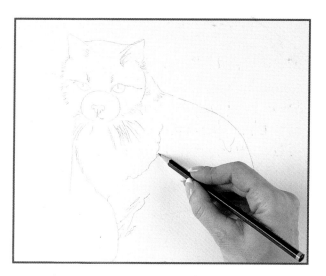

4 Because of the tooth in the paper, the pencils will wear down quickly, so sharpen them often. Continue to work over the entire cat, defining the outline of the face, the pupils, the whiskers and the angle of the tail. Keep the pencil pressure light. Notice that the markings on the cat's body run diagonally towards his front paws. Double-check all the outlines and markings against the photograph again. If you are content with the linear marks that you have made so far, you are ready to go on to the next step.

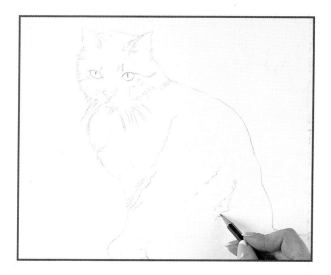

5 With the 4B pencil begin to build up the dark patches of fur. Use more pressure on the pencil for the darker areas. Vary the types of marks you make, suggesting surface pattern, texture and shadow. Go over some of your earlier marks, strengthening some of the lines. In order to see how your drawing is taking shape, stand back from it occasionally, or even leave it for a while. When you return, you will see it with fresh eyes and can adjust any mistakes.

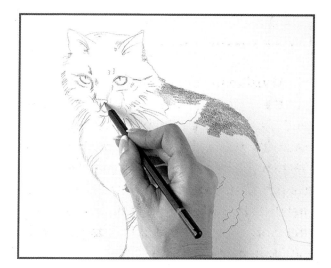

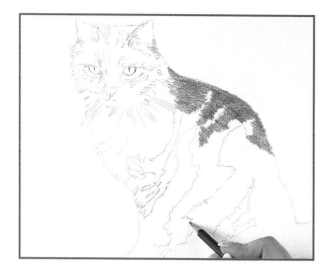

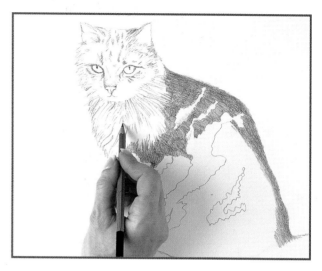

6 You need to keep all outlines soft, so erase any heavy or prominent lines. Using the point of your pencil, lightly draw the rest of the cat's markings. Keep moving around the cat, so that you don't add too much emphasis in any one area. Soften the ears with some light lines – feel free to erase harsher lines that you may have put in earlier. Notice that the markings on the cat's back are darker along the spine line, and create an illusion of depth. This shading is achieved with loose scribbles, up and down, until no white paper is left showing through.

Artist's tip
With all animals, first draw the shape, tones and features before proceeding to the detail of a patterned surface. In some cases you may need to be precise with these markings, but with a fluffy tabby cat such as this one, as long as you observe the general shapes and positions of the markings, you need not be exact.

7 Using the 6B pencil, continue to place and darken the cat's markings, still working over the entire body. Use the side and point of the pencil. Build up the shapes and textures with both line and tone. To achieve the large tonal areas, simply colour or render in fairly scribbled marks, up and down. Gently shade on either side of the nose and around the ears, using the sharp point of the lead for whisker lines and beneath the chin, and short, hatched lines for the fur on the top of the head. Continue to fill in the darker markings on the body; ensuring that beneath the body, on the spine and between the front and back legs, is slightly darker to give the illusion of shape. Use short, dashed lines to show short fur, add a few dots on the area beneath the nose and flick on a few light whiskers. Use the 6B pencil to define the eyes, nostrils and markings on the top of the head. Using the 2B pencil, lightly shade around the eyes, giving them their spherical appearance.

TRY A DIFFERENT ...

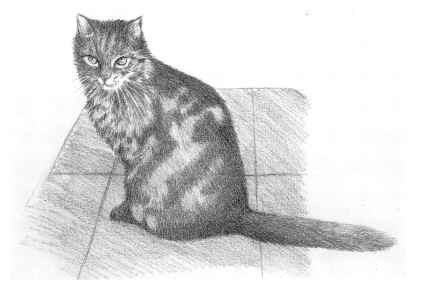

... MEDIUM

Try drawing this same image with coloured pencils. Use dark blue or grey for the undertones – shade the darkest areas first and then layer black or brown for the fur on top. Use some pale pink on the nose and inside the ears and green-yellow for the eyes. Leave some lines of the background paper showing through to indicate whiskers and use a mid-brown for the lighter markings on the coat. If this begins to look too heavy, colour over the top with a white pencil to soften it. Colour in gently, layering smooth strokes over each other to build up the tones.

... IMAGE

One of the best lessons you can give yourself when learning to recognize tones on an animal is to draw from a black and white image. Immediately, the dark and light tones become apparent and it can be quite surprising when you see just how tone varies. One of the most common inaccuracies made by beginners is to keep all the tones around the mid-mark without stretching to the extremes. This tends to make an animal look flat and unrealistic. Keep squinting at your drawing to see the contrasts clearly.

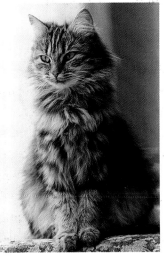

Demonstration 7

Puppy *Pencil*

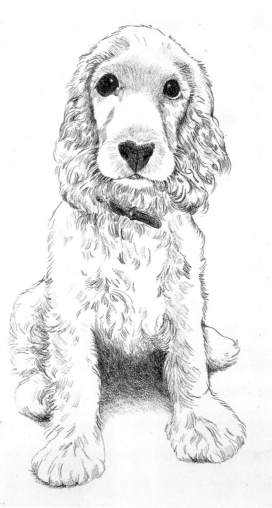

Regular practice will make you familiar with the versatile nature of pencils and you will find that you become more dextrous and comfortable with them fairly quickly. Because they can be both expressive and vigorous and soft and velvety, they are the ideal medium for puppies. This drawing builds up from a simple linear sketch to a more detailed, tonally textured drawing. Keep your lines loose and light so that you can erase any mistakes easily, but try not to become too meticulous. Some "wrong" lines give

vitality to a pencil drawing, especially with a young and lively subject such as this.

If you can persuade a puppy to sit for you (however briefly) scribble down a few visual notes, such as the angle of the head, the position of the paws or the shape of the nose and eyes. Never draw with a heavy, solid outline, but use broken lines and short and long marks to describe the texture and weight of the puppy.

Every animal has its own character. If you are drawing somebody else's pet, talk to the owner. As well as using correct proportions and tones to create a likeness of each animal, you have to try to catch the essence of their personality. This can be shown through the eyes, size of the paws, tilt of the head and so on. It is invariably something subtle – such as the angle of the eyebrows or curve of the mouth. Puppies are loyal, affectionate, amusing and trusting. This is quite a range of emotions to capture in a drawing, but it can be achieved if you work carefully and notice subtle angles and lines.

Subject

One of the cuddliest of all animals, a puppy has large trusting eyes, an ungainly head and paws and soft fur, all of which add to its appeal. As with any animal drawing, you need to break the puppy down into manageable geometric shapes. Although in most poses this cocker spaniel would be a rectangular box on stumpy legs, in this position the shape is more of a triangle or cone. Her character is revealed partly through her large paws, but mainly through her facial features.

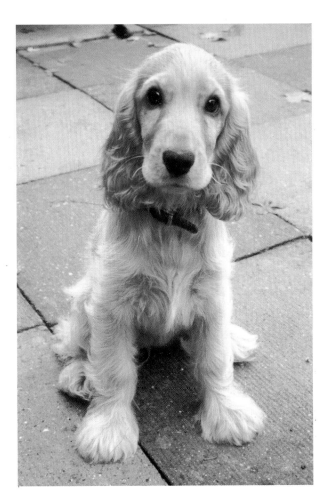

Materials

2B, 3B, 4B and 6B pencils

Sheet of smooth cartridge (drawing) paper 420 x 297mm (16½ x 11¾in)

Plastic eraser

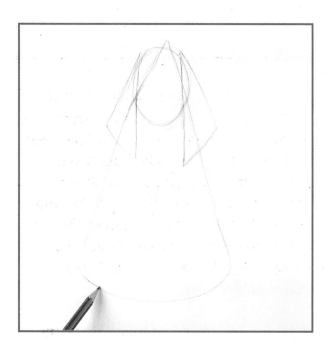

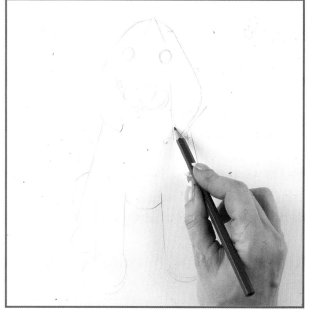

1 Using the 2B pencil, lightly mark on the cone-shape of the puppy in about the centre of your paper. One of the benefits of using photographs for a drawing like this is that the animal won't walk away from you, so make good use of the photograph to compare distances and proportions. For example, the amount of space between the legs, the length of the nose and ears and the shape of the head.

2 Soften the triangular shapes that make up the puppy's ears and body. Measure the distance between the eyes and between the nose and the eyes and mark these on. Compare distances between the nose and eyes and eyes to the top of the head. Then measure the length of the ears and compare them to the length of the front legs. Go over the guidelines, softening the straight lines with a few curves as you see them.

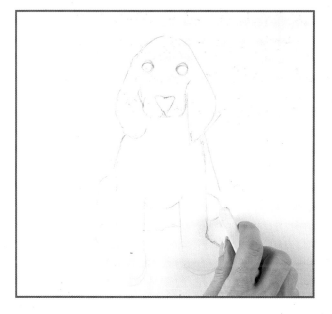

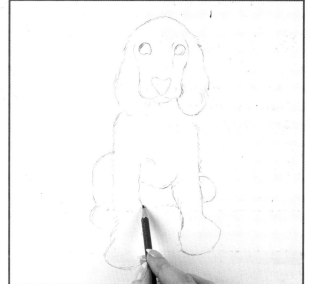

3 You should be aware that the image of this puppy is foreshortened. For example, the head seems a little larger in comparison to the hind legs because the head is closest to us. Shape the nose and eyes, the dome of the head and the inverted dome shape of the chest. Use broken lines to build up a more realistic outline and then erase your original guidelines.

4 Now using the 3B pencil, use broken lines to indicate fur. Shorter lines need to go on the body and longer, wavy lines need to go on the ears to render the different types of fur. Shape the eyes into their characteristic teardrop shape and the nose into its heart shape. For now, leave the paws as rounded ends to the legs. Check and reshape the chin, ears and back legs as necessary.

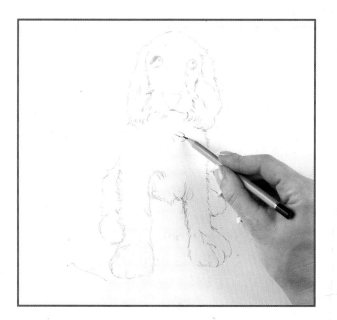

5 Change to the 4B pencil and continue around the puppy's outline with broken lines to build up the look of fluffy fur. Puppies' fur is softer than that of adult dogs and their paws and eyes appear larger in comparison to the rest of their bodies. To indicate whiskers, erase some gaps around the muzzle and draw short lines emerging almost at right angles to this. When you have established the fur, you may have to erase the more solid lines you have already drawn, such as the chin, perhaps redrawing them as a series of small dashes. Mark on the bit of collar that you can see.

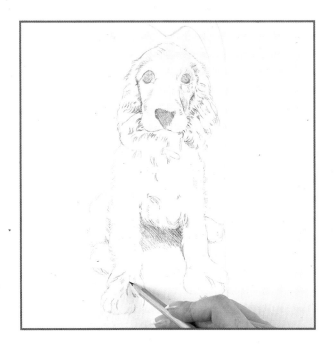

6 Lightly shade the nose and eyes. Be careful to keep this simple and to observe and maintain the puppy's vulnerable and trusting expression. This puppy has large, rounded eyes, a soft outline and soft, slightly questioning, eyebrows. Still with the 4B pencil, use short strokes in the direction of the fur growth in the darkest places, such as around the ears, under the chin and under the belly.

Artist's tip

Be patient when you are trying to recreate texture, whether it needs to look soft, as with this puppy, or coarse. Simple dashes – curved or straight – are all that is needed. The process may seem tedious and time-consuming, but persevere and the texture will begin to appear.

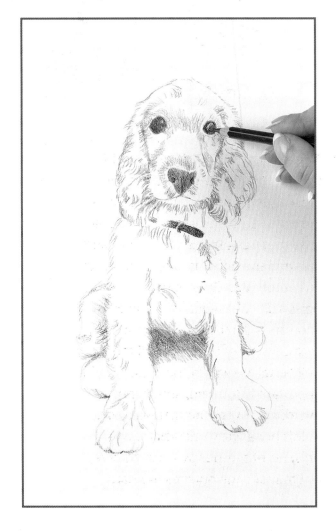

7 With a sharpened 6B pencil, pick out the darkest areas. Shade the eyes, leaving a dot of white highlight, darken the nostrils and the part of the collar that is showing and add some dashes of fur to the paws, beneath the body and on the ears and head. Don't smudge the pencil, but use a change of pencil pressure where you want smoother or darker tones. Although you will not have to shade all over the animal, you do need to denote some fur on the body, so do this with a few flicks of the pencil here and there, particularly on the breastbone area. Shade under the puppy to give it something solid to sit on and to prevent the image from appearing to "float". You don't need to include too many details in the background or it will detract from the subject.

TRY A DIFFERENT ...

... MEDIUM

Using pastel pencils and a blue-grey textured and tinted paper, draw the same puppy lightly in pencil first, so that you can erase any mistakes. When you're happy with the shapes and proportions, use a honey-coloured pastel pencil for the first outlines and then add some warm brown or tan pastel in short wavy strokes for the medium to dark areas. For the darkest tones, use a dark grey or brown pastel pencil (not black or you will flatten the picture). If you have a navy pastel pencil use this in the darkest areas with some brown over the top.

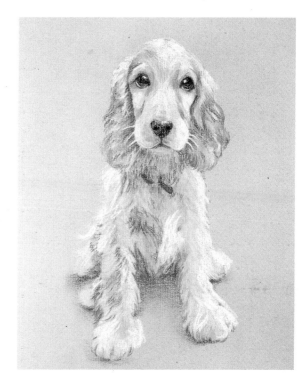

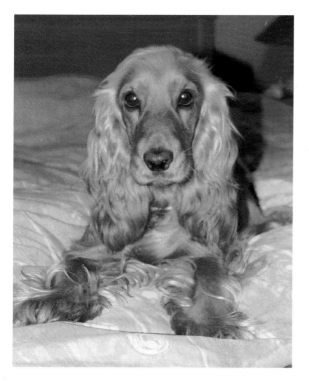

... IMAGE

Try drawing the puppy like this. Its body is foreshortened but, like the rabbit (see page 30), any distortions in shape can be explained by relevant tones. Notice the size of the eyes and ears and the differing directions of fur. To capture this lively puppy's personality be careful with the eyes and ears – don't over-exaggerate them. Also, notice how small the highlights are within the eyes. They're important but, again, should not be overdone. Any of the materials used in this book will work well for a drawing of this puppy – just be sure not to make the outlines too hard.

Demonstration 8

Horse *Conté crayons and sticks*

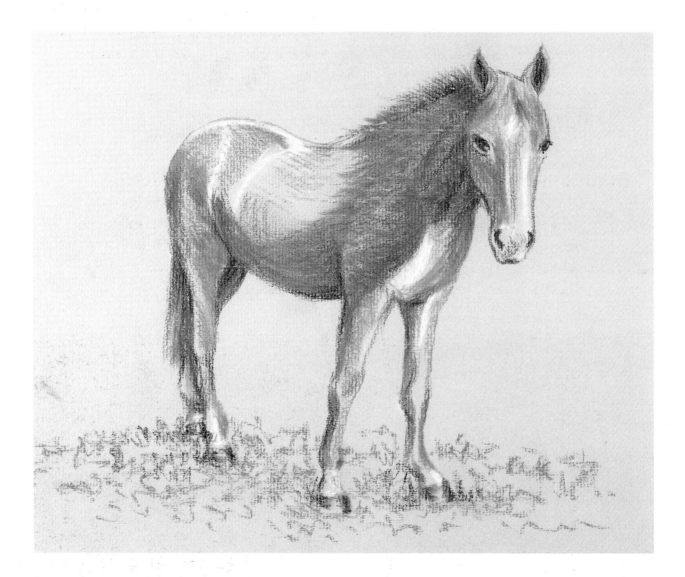

A common belief is that horses are difficult to draw, probably because of their proportions – large body and thin legs. However they can be relatively straightforward, once you establish where the legs are attached to the body and where the head fits on to the neck and so on. Understanding a little of the structure is helpful so, if possible, study pictures of horse anatomy in books or have a look in the natural history departments of

museums. And, whenever you can, study these graceful animals in life, taking photographs that show the way they move and hold themselves.

A good habit to get into is to draw parts of horses over and again to get used to their physical make-up. Quick scribbles are enough as they're only for reference. While drawing, try to bear in mind the skeleton. Remember such things as the length of the neck, the way the ears are set on the head, how the legs are formed and so on.

Subject

Horses and ponies, like most species, come in many shapes and sizes. A Shire horse and a pony, for example, are proportionally different. And the striking chestnut horse in this photograph is different again. Conté is an excellent medium for this subject: it allows you to work fairly rapidly, being quite free in the way in which you work, without having to include great detail. A few loose gestures will describe shapes and tones quickly. Use a coloured paper and a limited range of colours for best effect. At every stage of the drawing, compare the length, width and shape of various areas to maintain the correct proportions.

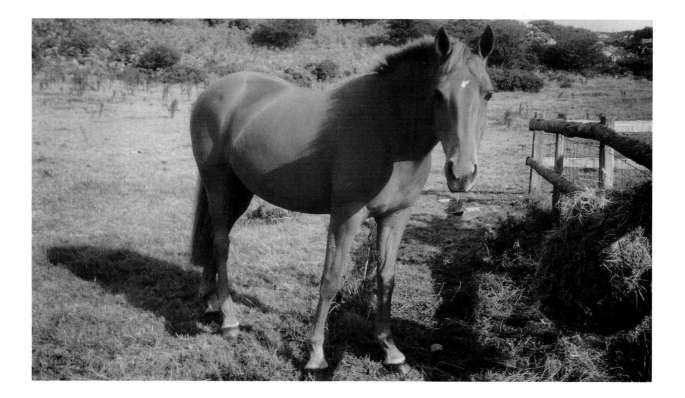

Materials

2B pencil

Conté crayons and sticks:
black, dark brown (umber),
mid-brown (sepia),
light brown (tan),
ochre, grey-green

Sheet of beige pastel paper
230 x 300mm (9 x 12in)

Plastic eraser

Fixative

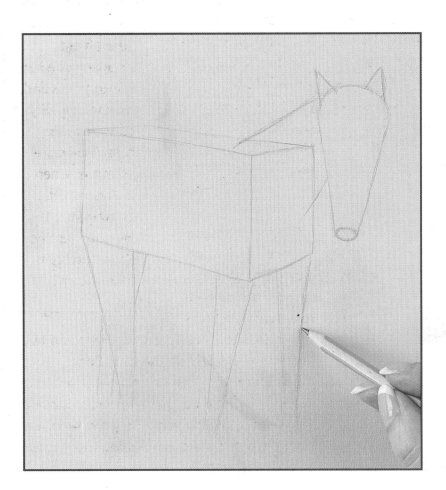

1 Traditionally, you would not start a Conté drawing with a pencil, but as you can erase any mistakes easily this is a good medium for beginners to start with. Take the sharpened 2B pencil and begin by studying the photograph. Imagine the horse as various simplified geometric shapes. It helps to draw these in lightly as you place the animal on the paper. Look all around the image, concentrating on the negative shapes around the outline as well as the bulk of the body. Lightly draw this, not worrying about any tricky curves or angles for the time being.

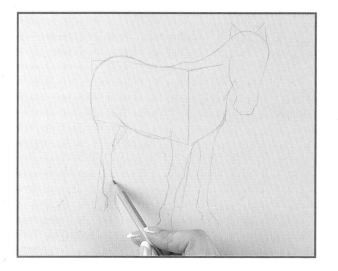

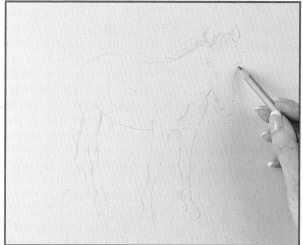

2 Begin to draw the curved shapes of the horse using the geometric shapes as guides. This horse is slightly foreshortened with the hindlegs looking smaller than the forelegs. Legs of horses are notoriously a problem for many beginner artists, but they needn't be. Simply look at how slender they are in comparison to the rest of the horse's body and how they don't meet at the top in the way that human legs do. These legs are particularly delicate looking. If you were drawing a Shire horse, or even a Shetland pony, the legs would appear to be sturdier.

3 Take your time and don't lose patience. If you make a mistake, erase it. Use broken lines so that you can stop if you feel you're not going in the right direction. They will also give the drawing a livelier look. Erase the guidelines when you are satisfied with the "correct" curved shapes you have drawn. Calculate and mark the positions of the horse's eyes.

Artist's tip
Be aware of where the light falls and how the highlights curve over the body. Half close your eyes when looking at the photograph; this will show up the darks and lights more clearly.

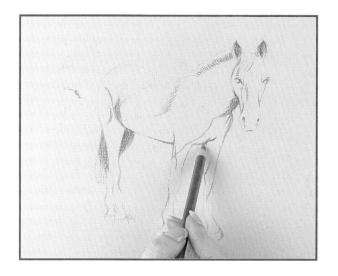

4 Using the sepia and black Conté crayons, mark on some of the darkest-toned areas, such as under the horse's belly, on the mane and tail, under the neck and on the ears. Conté crayons and sticks can be chalky or even scratchy, so use an extra light touch, drawing lots of short, broken lines. They can be given further emphasis later, by adding more lines on top if necessary.

5 Always compare one body part in relation to another so that your proportions are correct. Using the tan or sepia Conté stick, continue laying down some soft lines on the legs, body and head, to render the lighter chestnut tones on the horse. Don't worry about being exact – just mark areas that you can relate to in the photograph. Draw some little dashes around the hooves with the grey-green Conté stick, to represent grass.

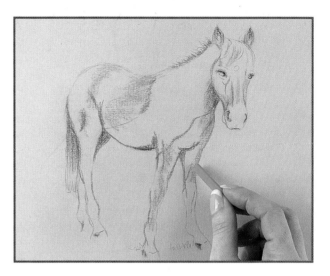

6 Continue with the tan Conté stick, constantly moving across the horse and layering your strokes so that they blend into each other. To define the darkest areas, half close your eyes and squint at the subject. Then, with the dark brown Conté crayon, lay longish marks under the face, on the hind-legs and on the tail. Use the white Conté to mark on highlights. Remember to use a light touch – you can always layer more colours on, but it is not so easy to remove them.

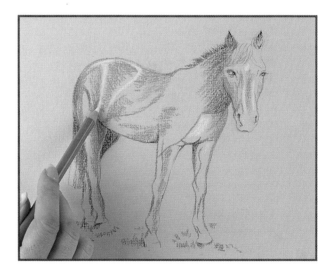

7 Using the brown Conté crayon, shade under the belly, the backs of the legs and around the ears. Build up depth and tone by using colours in layers, such as brown, then ochre, then sepia. Don't overload the paper with colour; just apply it a little more heavily on the darker parts of the horse. Build up the final image with short, dashed strokes laid on top of others. Use highlights and dark tones to create the horse's rounded, glossy appearance and let the tinted paper show through for mid-tones.

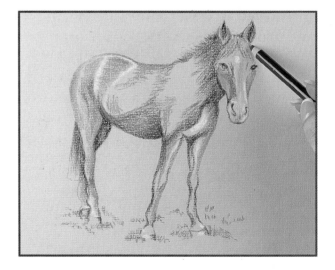

TRY A DIFFERENT ...

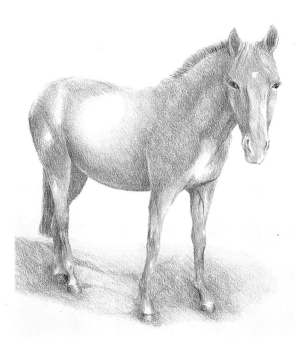

... MEDIUM

To produce the same horse portrait using coloured pencils you can use smooth white paper. Apply a variety of browns with blues and greys mixed in for the darkest areas, rather than black. Leave the white paper showing through for highlights. For a smooth area of tone – whether medium, light or dark – get into the habit of using broken lines, soft strokes and even gentle swirls, and never press hard. I used an olive-green coloured pencil to scribble on some hatching for a hint of grass, but a similar effect can be made with yellow layered over blue.

... IMAGE

This horse, bending to graze, is in a good position to draw, particularly in terms of proportion. Black animals are always a challenge and can easily appear as flat silhouettes if the highlights are not rendered accurately. If drawing this in a coloured medium, try using blue with black. Before you begin to draw, look for measurements and proportions. For example, in this horse the length of the head equals the length of the neck from the base of the ear to the shoulder and its height is about two and a half times the length of its head.

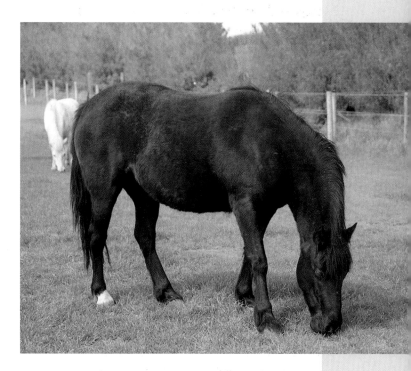

Demonstration 9

Dogs *Coloured pencils*

By now, you will have an understanding of
how to look at all animals when beginning
to draw them. It takes time to get used to
observing, not just in terms of simple shapes,
but also for subtle changes in tonal value. As
you look for the shapes that make up the

animal, you should also note the tonal
shapes that are part of the whole image.
Look at the photograph and decide where
the light is coming from and also where any
shadows fall. Shadows are not the long grey
shapes that most of us drew when we were

children, they are usually far subtler than that. Sometimes they are made up of reflected colour – that is, colour from objects near to the subject, or they are made up of complementary colours, such as blue in the shade of an orange object. Usually, coloured pencils work best when layered to create subtle tones.

Shadows, colour shapes and negative spaces all affect the completed image. They also make a difference to the composition or layout of the picture. How the drawing is constructed and arranged on the paper determines how the picture is perceived.

Whatever animal or group of animals you are drawing, there are certain basic rules about composition; rules that will make the picture more appealing and interesting to look at. In general, place the animal or group in the centre and your drawing should take up most of the paper. Any background should not detract the viewers' eyes away from the subject. It is for this reason that I decided not to include the background in my drawing of these dogs. As you become more proficient you can play around with these rules, but to start with, stick to these principles.

Subject

In addition to the main principles of drawing animals, such as understanding an animal's anatomy, looking for negative shapes and thinking about what makes a good composition, you should also consider what kind of feeling you want from a picture.

In this case, how will you portray the dogs' characters? This group seems as amused by us as we are by them! Dogs' shapes, sizes and appearances vary more than those of any other animal and their personalities show through their stance, the way they hold their heads and even their facial expressions. When you draw any dog you should first think about the kind of character you are drawing and how to convey it.

Materials

2B pencil

*Coloured pencils – black,
light and dark grey, red and dark red,
light and dark brown, green*

*Sheet of smooth cartridge (drawing)
paper 420 x 297mm (16½ x 11¾in)*

Plastic eraser

1 These three King Charles spaniels are full of fun and mischief. Their position is good for a drawing as they are close together. This makes them almost one large shape, which helps when you are looking at the negative spaces around them. Leave out the detailed background and concentrate on the dogs themselves. As with most drawings in this book, the composition is simple, with the subject centralized. As always, begin by establishing simplified geometric shapes and draw these lightly with a 2B pencil.

2 Note the proportions of the dogs, for example, the length of the legs, shapes of the heads and ears. Even measure the negative spaces around the heads and under the ears. Go over your guidelines, drawing inside the circles you have drawn for the muzzle areas, shaping the noses and mouths, beginning to shape the legs and to place the eyes and eyebrows to establish expressions. Lightly mark on the parts of the collars that you can see and the discs hanging from them. Draw some "S"-shaped curves to mark the ears.

3 Add detail to the shapes of the noses. Draw with sketchy zigzags to indicate areas where the fur is longer. By studying the anatomy of the dogs you will get a clearer idea of their shapes. For example, measure more carefully where the eyes come in proportion to the nose, mouth and ears and adjust these if necessary. Begin to give more shape to the features, always checking distances and negative shapes.

4 Establish the facial expressions by drawing the mouth lines and eyebrows. Draw the paws too, lightly to start with. Draw only what you see, not what you imagine paws to look like. If you make a mistake, erase it and draw it again. When you're happy with the initial drawing, take the light brown pencil and, working on the left-hand and centre dog, start to shade lightly in small patches to build up the impression of fur.

5 Start layering on top of the light brown with mid-brown to render the darker tones. Be aware that you are trying to make your drawing appear three-dimensional, and the way to achieve this is by showing dark and light tones. Note where the darker tones are, for instance in between the eyes, under the ears and on the inside of the legs. Try to end your wavy lines by flicking the end of the coloured pencil where the fur ends. Don't worry about being too neat here; just don't overdo the colour.

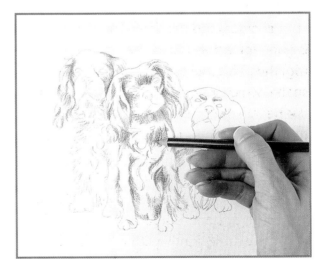

6 Continue colouring the fur in patches with the mid-brown, but leave gaps of white paper showing through. With the black coloured pencil, use wavy lines to mark on the darker fur on the right-hand dog's ears, in all of the dogs' eyes and in little patches on their noses. Use black curves to indicate the discs on the collars. Only draw part circles here, to indicate shadow away from the light. Next, use the red pencil to colour in the two or three broken lines that form the collar showing through the fur of each dog.

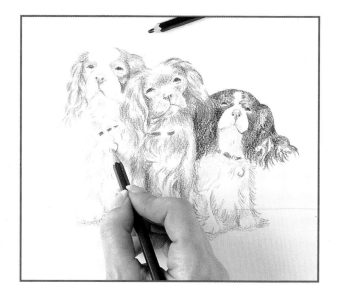

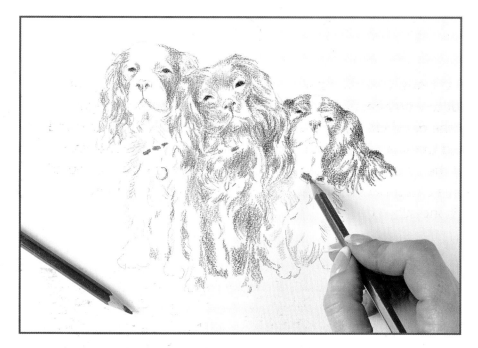

7 Now use the light grey pencil to mark on wavy "fur" lines on the two outside dogs' bodies. Go carefully and leave plenty of paper showing through. Add a little under their chins, on their noses and some around the mouths to indicate shade. Anchor the dogs on the paper (so they don't appear to be floating) by using the dark grey around their paws. If you have kept a light touch the paper showing through will denote highlights. This gives the picture a light feel and doesn't detract from the dogs' witty stance and expressions. Shade in the collar discs with light grey and, if necessary, use the 2B pencil once more to "firm up" some of the details. Finally, lightly and sketchily, shade around the paws, over the dark grey in green, blending away to nothing.

Artist's tip
Make sure that your outlines are not darker than the animals and try to keep your rendering loose and free rather than detailed – otherwise you may end up with a flat and lifeless image.

TRY A DIFFERENT ...

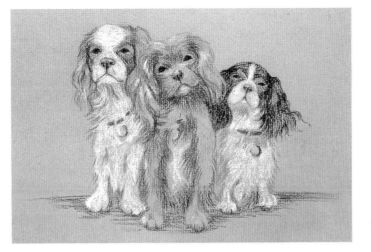

... MEDIUM

By using Conté sticks and crayons, you'll find that these dogs will come to life on your paper fairly quickly. Try not to worry about making mistakes, but mark on loose, light strokes in the direction of the dogs' fur. Try to imagine the skeleton of the dogs; how and where are the legs attached to the bodies, what shapes are the tops of the heads, what are the distances between the eyes, noses, mouths and ears, for example? Use a coloured, textured paper and let some of it show through – a looser, lighter touch is far more effective with this medium and subject.

... IMAGE

The contrasting colours of this handsome dog will make a wonderful portrait. Try using a coloured medium, adding blue to the shadows rather than flat black. If you're drawing the image in pencil or graphite, try using a 6B for the darkest tones and a B for the lighter tones. Note the darkness of the space above the tongue, under the back leg, within the nostrils and next to the highlights in the eyes. Be aware of the shorter and longer areas of fur.

Demonstration 10

Kitten *Coloured pencils*

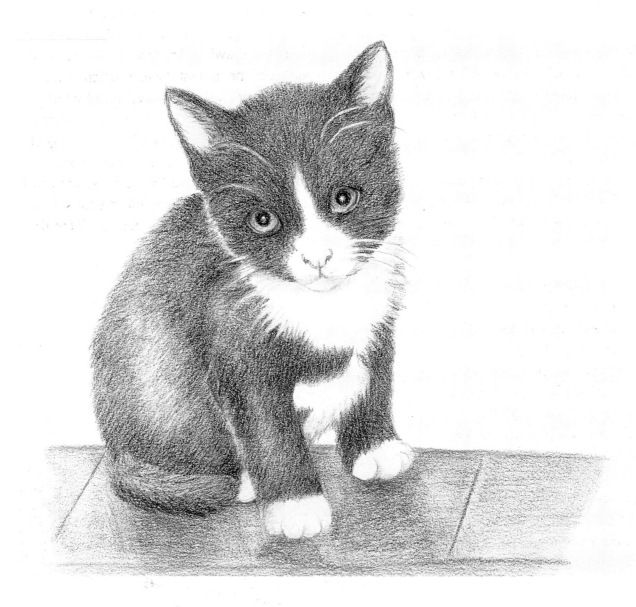

To create a soft look for a young animal, work lightly and layer colours where you want more depth or definition. This usually means starting with the lighter colours and progressing to darker ones. There is an effect called "burnishing", however, where colour is applied more firmly to the paper, with lighter colours being used on top of darker

ones, blending the pigments smoothly into each other. Hatching, cross-hatching and stippling also work well. As with most materials used in this book, it is best to build up the surface image gradually, starting with light marks and allowing plenty of paper to show through. Work over areas where you require more depth. To depict fur accurately in coloured pencil takes time. But with patience and perseverance, the effect can be convincing.

As young animals are particularly lively and adventurous, you will need patience if you draw them directly – and even if you take photographs – as they will rarely stay in one place for long. Use a large sheet of paper or sketchbook and try to capture the essence of the animal's shape and lines with a quick sketch containing few details, then move on to a fresh drawing. Try to look at a different aspect of the animal in each sketch. That way you will build up a very useful set of reference drawings. When drawing, whether quickly or slowly, try to look at your subject as often as possible and rarely at your drawing. This is far easier than it sounds and will teach you a lot more about your subject than if you looked at your drawing all the time.

Subject

Kittens, with their big eyes, small mouths and soft little paws, can look cute and adorable. But drawing them is another matter; they move often and quickly. Their curiosity is legendary, which adds to their charm. If you do manage to capture a kitten on camera, it is sometimes difficult to determine the softness of the fur, or details of the paws or mouth. Also, as with all animals – but particularly with young ones – the flash of the camera can be startling, so should be avoided or kept to a minimum.

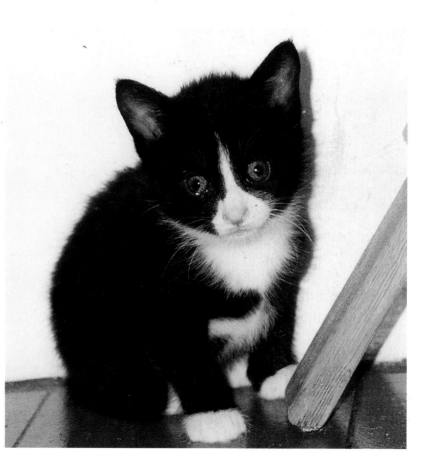

Materials

2B pencil

Coloured pencils – black, ultramarine blue, grey, pink or peach, brown, reddish-brown

Sheet of smooth cartridge (drawing) paper 420 x 297mm (16½ x 11¾in)

Plastic eraser

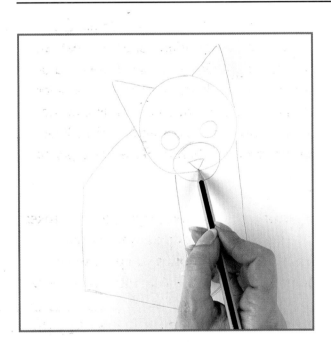

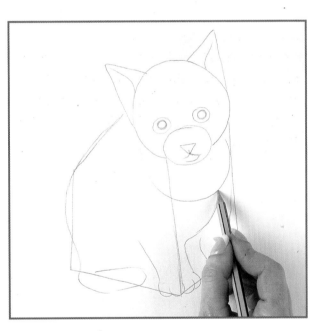

1 This kitten is foreshortened; the head appears larger than the rest of the body and the back slopes away. Envisage the kitten on your paper to establish the size of your drawing. With the 2B pencil, lightly mark on the basic shapes, noting the proportions. The blue eyes are round, the mouth area particularly small and the whiskers fine.

2 Mark in the circular pupils and the mouth and begin to shape the paws and ears. Mark on the little "bib" shape of the chest and the upside down "Y" of the mouth. Keep your lines light and fluid – remember that one continuous line will be unwieldy and will give the impression of stiffness. Note the curve of the spine to the tail.

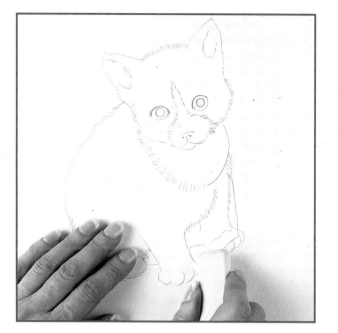

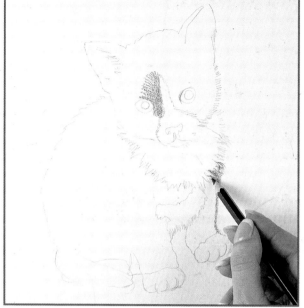

3 The reason for using a pencil for these initial lines is so that any mistakes can be erased and altered easily. Keep the pencil sharp and go over the "flat" outlines with little dashes to indicate fur. When you feel confident with the basic drawing, erase all initial geometric guidelines.

4 Before you add too much detail, check your proportions and alter any that are not quite right. For example, if the head or ears are too small, the kitten will look older than it really is. Work on the outline of the body, using soft zigzags and hatched lines for fur and then change to the black pencil.

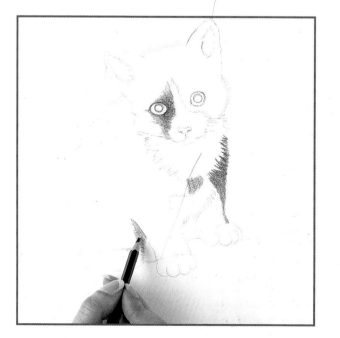

5 Work over the body, laying down strokes of black in a back and forth motion, lightly filling any gaps as you go. Sketch pointed ellipse shapes within the ears. Keep your pencils sharp and use the side of the point for denser rendering. Don't dwell on any one area, but keep moving across the entire animal. Remember at all times that this is a young animal, with short, soft, baby fur and fewer obvious tones – it is more rounded altogether.

Artist's tip
Always work lightly with coloured pencils, layering the colour loosely. If you are too heavy-handed, it will be difficult to build up colour and tone.

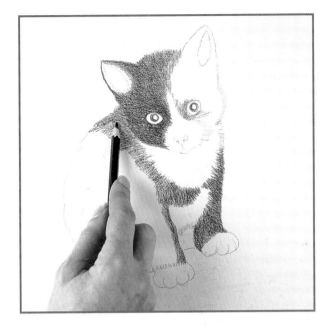

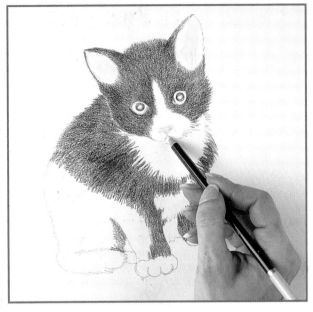

6 Continue to shade the black fur with the black pencil, keeping the pressure light and covering all the paper in those areas. Define the eyes and circular pupils, leaving a central area for the highlight. Work in the direction of fur growth so, for example, the fur on the head points backwards. Use short hatching lines for short, soft fur.

7 The strong darks make the lighter areas appear brighter and as the white paper zigzags into the black fur the picture comes to life. Take the pink or peach pencil and, still using light pressure, shade the nose, mouth and the insides of the ears. Build up some darker tones to create the impression of solidity. Press a little harder on darker areas.

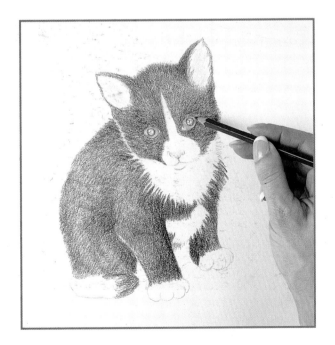

8 With the blue, lightly colour the irises, using the point of the pencil to define the edges of the eyes. With the peach or pink pencil, introduce a deeper line at the base of the nose. Finish the picture by adding further tones to show the roundness of the kitten and some deeper blue on the eyes. Using the grey pencil, shade a little under the chin, under the paws, on the chest and within the ears. Mark on the tiles as a base, which has the effect of anchoring the kitten on to the paper. You do not need to do this in detail, just use some reddish-brown, divided by brown and add some grey for shadow.

TRY A DIFFERENT ...

... MEDIUM

Now that you are familiar with looking at animals in an objective manner, you will find it easy to see simple shapes in their outlines. Using a range of soft pencils, draw the basic, rounded outline. Leave out the detail until you are happy with the basic shape. Then gradually build up the fur with curved, hatched lines in the direction of growth. Where the kitten appears to be darker toned, use a softer pencil and go over those areas several times. Grip the pencils well back from the drawing point and make lots of marks all over the image. If you make a mistake don't be too quick to erase; sometimes working over "wrong" lines enhances the right ones.

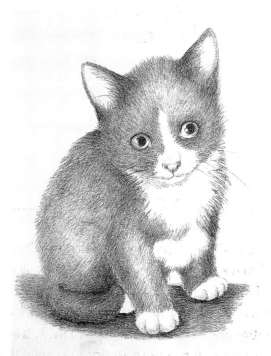

... IMAGE

This is the same kitten doing what kittens do best – climbing and being curious. For this drawing, you have the best of both worlds – an impromptu, unplanned pose captured in a photograph that allows you to create a controlled drawing. Whatever materials you work in, be sure that you get the proportions right to begin with. By now you will be able to make expressive linear marks and softly graded tones. Try not to overwork this picture as the subject of a little cat on the move lends itself to a more unfinished look. The trick here is to finish before you think you should!

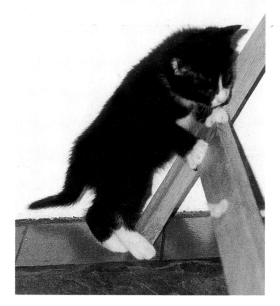

Suppliers

UK

The Arthouse
59 Broadway West
Leigh-on-Sea
Essex
SS9 2BX
Tel: (01702) 071 2788
Wide range of art supplies

Cass Arts
13 Charing Cross Road
London WC2H 0EP
Tel: (020) 7930 9940
&
220 Kensington High Street
London W8 7RG
Tel: (020) 7937 6506
Website: www.cass-arts.co.uk
Art supplies and materials

L Cornelissen & Son Ltd
105 Great Russell Street
London WC1B 3RY
Tel: (020) 7636 1045
&
1a Hercules Street
London N7 6AT
Tel: (020) 7281 8870
General art supplies

Cowling and Wilcox Ltd
26-28 Broadwick Street
London W1V 1FG
Tel: (020) 7734 9556
Website: www.cowlingandwilcox.com
General art supplies

Daler-Rowney Art Store
12 Percy Street
Tottenham Court Road
London W1T 1DN
Tel: (020) 7636 8241
Painting and drawing materials

Daler-Rowney Ltd
PO Box 10
Southern Industrial Estate
Bracknell
Berkshire RG12 8ST
Tel: (01344) 424621
Website: www.daler-rowney.com
Painting and drawing materials
Phone for nearest retailer

T N Lawrence & Son Ltd
208 Portland Road
Hove BN3 5QT
Shop tel: (01273) 260280
Order line: (01273) 260260
Website: www.lawrence.co.uk
Wide range of art materials
Mail order brochure available

John Mathieson & Co
48 Frederick Street
Edinburgh EH2 1HG
Tel: (0131) 225 6798
General art supplies and gallery

Russell & Chapple Ltd
68 Drury Lane
London WC2B 5SP
Tel: (020) 7836 7521
Art supplies

The Two Rivers Paper Company
Pitt Mill
Roadwater
Watchet
Somerset TA23 0QS
Tel: (01984) 641028
Hand-crafted papers and board

Winsor & Newton Ltd
Whitefriars Avenue
Wealdstone
Harrow
Middlesex HA3 5RH
Tel: (020) 8424 3200
Website: www.winsornewton.com
Painting and drawing materials
Phone for nearest retailer

SOUTH AFRICA

CAPE TOWN
Artes
3 Aylesbury Street
Bellville 7530
Tel: (021) 957 4525
Fax: (021) 957 4507

GEORGE
Art, Crafts and Hobbies
72 Hibernia Street
George 6529
Tel/fax: (044) 874 1337

PORT ELIZABETH
Bowker Arts and Crafts
52 4th Avenue
Newton Park
Port Elizabeth 6001
Tel: (041) 365 2487
Fax: (041) 365 5306

JOHANNESBURG
Art Shop
140ª Victoria Avenue
Benoni West 1503
Tel/fax: (011) 421 1030

East Rand Mall Stationery and Art
Shop 140
East Rand Mall 1459
Tel: (011) 823 1688
Fax: (011) 823 3283

PIETERMARITZBURG
Art, Stock and Barrel
Shop 44, Parklane Centre
12 Commercial Road
Pietermaritzburg 3201
Tel: (033) 342 1026
Fax: (033) 342 1025

DURBAN
Pen and Art
Shop 148, The Pavillion
Westville 3630
Tel: (031) 265 0250
Fax: (031) 265 0251

BLOEMFONTEIN
L&P Stationery and Art
141 Zastron Street
Westdene
Bloemfontein 9301
Tel: (051) 430 1085
Fax: (051) 430 4102

PRETORIA
Centurion Kuns
Shop 45, Eldoraigne Shopping Mall
Saxby Road
Eldoraigne 0157
Tel/fax: (012) 654 0449

AUSTRALIA

NSW

Eckersley's Art, Crafts and Imagination
93 York St
SYDNEY NSW 2000
Tel: (02) 9299 4151
Fax: (02) 9290 1169

Eckersley's Art, Crafts and Imagination
88 Walker St
NORTH SYDNEY NSW 2060
Tel: (02) 9957 5678
Fax: (02) 9957 5685

Eckersley's Art, Crafts and Imagination
21 Atchinson St
ST LEONARDS NSW 2065
Tel: (02) 9439 4944
Fax: (02) 9906 1632

Eckersley's Art, Crafts and Imagination
2-8 Phillip St
PARRAMATTA NSW 2150
Tel: (02) 9893 9191 or
1800 227 116 (toll free number)
Fax: (02) 9893 9550

Eckersley's Art, Crafts and Imagination
51 Parry St
NEWCASTLE NSW 2300
Tel: (02) 4929 3423 or
1800 045 631 (toll free number)
Fax: (02) 4929 6901

VIC

Eckersley's Art, Crafts and Imagination
97 Franklin St
MELBOURNE VIC 3000
Tel: (03) 9663 6799
Fax: (03) 9663 6721

Eckersley's Art, Crafts and Imagination
116-126 Commercial Rd
PRAHRAN VIC 3181
Tel: (03) 9510 1418 or
1800 808 033 (toll free number)
Fax: (03) 9510 5127

SA

Eckersley's Art, Crafts and Imagination
21-27 Frome St
ADELAIDE SA 5000
Tel: (08) 8223 4155 or
1800 809 266 (toll free number)
Fax: (08) 8232 1879

QLD

Eckersley's Art, Crafts and Imagination
91-93 Edward St
BRISBANE QLD 4000
Tel: (07) 3221 4866 or
1800 807 569 (toll free number)
Fax: (07) 3221 8907

NT

Jackson's Drawing Supplies Pty Ltd
7 Parap Place
PARAP NT 0820
Tel: (08) 8981 2779
Fax: (08) 8981 2017

WA

Jackson's Drawing Supplies Pty Ltd
24 Queen St
BUSSELTON WA 6280
Tel/Fax: (08) 9754 2188

Jackson's Drawing Supplies Pty Ltd
Westgate Mall, Point St
FREEMANTLE WA 6160
Tel: (08) 9335 5062
Fax: (08) 9433 3512

Jackson's Drawing Supplies Pty Ltd
108 Beaufort St
NORTHBRIDGE WA 6003
Tel: (08) 9328 8880
Fax: (08) 9328 6238

Jackson's Drawing Supplies Pty Ltd
Shop 14, Shafto Lane
876-878 Hay St
PERTH WA 6000
Tel: (08) 9321 8707

Jackson's Drawing Supplies Pty Ltd
103 Rokeby Rd
SUBIACO WA 6008
Tel: (08) 9381 2700

NEW ZEALAND

AUCKLAND

The French Art Shop
33 Ponsonby Road
Ponsonby
Tel: (09) 376 0610
Fax: (09) 376 0602

Takapuna Art Supplies Ltd
18 Northcote Road
Takapuna
Tel/Fax: (09) 489 7213

Gordon Harris Art Supplies
4 Gillies Ave
Newmarket
Tel: (09) 520 4466
Fax: (09) 520 0880
&
31 Symonds St
Auckland Central
Tel: (09) 377 9992

Studio Art Supplies
81 Parnell Rise
Parnell
Tel: (09) 377 0302
Fax: (09) 377 7657

WELLINGTON

Affordable Art
10 McLean Street
Paraparaumu Beach
Tel/Fax: (04) 902 9900

Littlejohns Art & Graphic Supplies
170 Victoria Street
Tel: (04) 385 2099
Fax: (04) 385 2090

G. Websters & Co. Ltd
44 Manners Street
Tel: (04) 384 2134
Fax: (04) 384 2968

CHRISTCHURCH

Brush & Palette Artists Supplies Ltd
50 Lichfield Street
Christchurch
Tel/Fax: (03) 366 3088

Fine Art Papers
200 Madras Street
Tel: (03) 379 4410
Fax: (03) 379 4443

DUNEDIN

Art Zone
57 Hanover St
Tel/Fax: (03) 477 0211
Website: www.art-zone.co.nz

Index